BASEBALL
IN
VENTURA
COUNTY

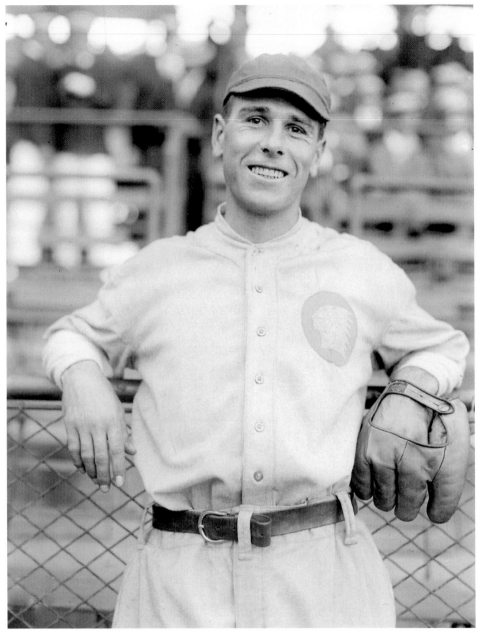

Fred Snodgrass finished his nine-year major-league career in 1916 with the Boston Braves, which, ironically, was in the same city where he committed his infamous error (see page 23).

BASEBALL
IN
VENTURA
COUNTY

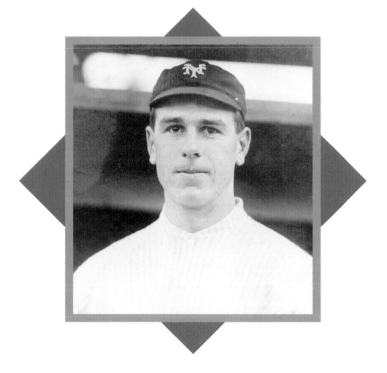

Jeffrey Wayne Maulhardt

ARCADIA
PUBLISHING

Published by Arcadia Publishing
Charleston, South Carolina

Printed in the United States of America

Library of Congress Catalog Card Number: 2006939747

For all general information contact Arcadia Publishing at:
Telephone 843-853-2070
Fax 843-853-0044
E-mail sales@arcadiapublishing.com
For customer service and orders:
Toll-Free 1-888-313-2665

Visit us on the Internet at www.arcadiapublishing.com

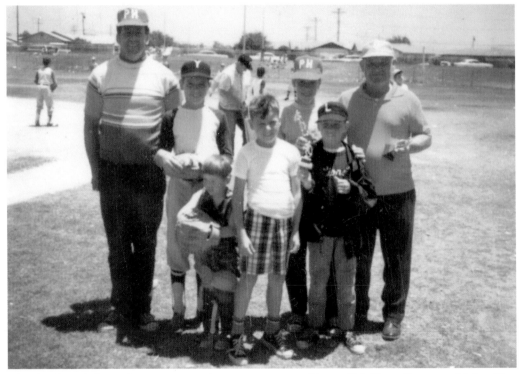

This book is dedicated to my original teammates, my siblings: Ed, Tim, Craig, and Julie. The "team" plus coaches seen in 1969 from left to right are coach Ken Perry, Jeff, Julie, Tim, Ed, Craig, and coach Harry "Mac" McDonald.

CONTENTS

ACKNOWLEDGMENTS

I want to thank many family members, friends, and new friends for sharing their images. Because I was denied access to some archives, the willingness of these true friends allowed me to complete this project in a manner that is respectable to the subject and its teams and players.

Thanks go to Joe Borchard Sr. for patience during telephone conversations and for the Stanford photographs; Bob Borchard for his scrapbook, story sharing, and contacts to his brother Joe Sr. and Dave Laubacher; Dave for the Santa Clara photographs borrowed from Dick "Jacq" Jacques; Scott Cline for graciousness and the championship booklet; Jim Colborn for the 1961 Santa Paula Merchants image and five autographed baseball cards; Eric Daily for sharing for the umpteenth time the photographs of the locals that only he has; Ernie Carrasco for the "Ernie Carrasco scrapbooks" and Jacob Cruz image; Roger Frash for the Oxnard American Legion team information from Jerry White and Buster Staniland and for Frash and Towers pictures and information; Craig "Moe" Maulhardt for photographs and cards from his archives and his sports bar, Sam's Saloon; Tim Maulhardt for names and numbers; cousin Alan Maulhardt for the Cardinal infield picture; Bob McGuire for the Ventura Braves "3 guys, 3 girls" photograph and the Ventura Braves 1950 financial report; John Nichols for the 1912 Santa Paula team picture and for introducing me to Arcadia Publishing several years ago; Joe Ortiz for the Adolfo Camarillo image and contact with "Tio" Cassie Ayala, who provided the Camarillo Blue Sox and Merchants pictures; Frank Naumann for the Ventura Braves photograph and certificate (Frank, I told you I could use it some day); Noble "Ace" Powell and his father-in-law, Bob Gill, for the Springville image with the all-important names; Dennis Porto for introducing me to Phil Marquez; Phil for the 1930s Ventura photographs; Jeff Tackett for the Tackett images; Terry Tackett for his bonus baby picture and role-model virtues; Steve Soliz for his contact to Dave Soliz; Dave Soliz for letting me borrow the Soliz archives; Jon Wood for the Don Rowe story and the Oxnard College clipping; Tony Vasquez for meeting me in Saticoy and for the Santa Paula and 1964 Oxnard Merchants images; David Wilhoit for confirming information about his great uncle Joe Wilhoit; Lynn Redmile, Andrew Gasper, and the Topps Company, Inc., for allowing me to use the images of the Topps baseball cards; Fleer for permitting the use of their cards in this book; Donruss cards and Upper Deck for their permission and quick response; and my little-league supporters, coaches Perry, Laut, Burch, McDonald, Stiles, Wieser, and Weigel. Special thanks goes to my wife, Debbie, for understanding that this book was important for me to do. And finally, a big thank-you goes to Jerry Roberts of Arcadia Publishing for keeping the lines of communication open.

INTRODUCTION

The sport of choice through generations for spectators and readers in Ventura County dates to October 1873, when a local newspaperman, Ed Sheridan, was named captain of the original "first nine." The *Ventura Signal* reported, "We are glad to note the fact that the lovers of the manly game in our town have organized a baseball club." The unavailability of players precluded a formal "second nine." But in these days of mitt-less bare hands, when the catcher played several steps behind the batter to catch the pitch on a bounce, baseball fever in Ventura County caught on quickly. In the first game, played on November 29, 1873, the Ventura Club beat a citizens group called the "picked nine" by a score of 56 to 17.

The first Ventura County player to make a paying career out of baseball—for over 20 years—was also the first to reach the major leagues. Charley "Clolo" Hall was born in Ventura and was the grandson of Santa Paula pioneer R. O. Hall. Charley began pitching for the Seattle Indians of the Pacific Coast League in 1904. After posting 28 victories as a 20 year old, the Cincinnati Reds bought his contract. By 1906, Hall was pitching in the major leagues. He was followed there by another Venturan, John "Jack" Barnett, from the pioneering Barnett family, who was listed in some baseball sources as "Burnett." He put in one year with the St. Louis Cardinals, participating in 59 games and posting a .238 batting average.

The next major leaguer from the county to reach the professional level was the most influential in spreading the love of the game in the area. Fredrick Carlisle Snodgrass, the grandson of banker and rancher Larkin Snodgrass, was born in Ventura, moved to Los Angeles as a child, graduated from Los Angeles High School, and then played ball for St. Vincent's College. While catching for St. Vincent's, the young, brash Snodgrass made an impression on New York Giants manager John McGraw, who was on the West Coast to bet on horses and scout for players. After umpiring a game in which Snodgrass's talent surpassed the competition, McGraw offered him a contract. Snodgrass made his debut in 1908 with the Giants, and closed his career nine years later with the Boston Braves. By this time, Snodgrass had bought a winter home in the El Rio/Oxnard area. He was instrumental in bringing the touring Giants and White Sox to Oxnard in 1913 for an exhibition game that brought Ventura baseball excitement to a fevered pitch.

In 1916, during Snodgrass's final year in the majors, Santa Paula outfielder Joseph Wilhoit signed a contract with the Boston Braves. Wilhoit's career in the big leagues was short, but his impact on professional baseball survives to this day. By 1919, Wilhoit had seen action with the Braves, Pittsburgh Pirates, New York Giants, and Boston Red Sox. After only six games with the Sox, he was dealt to the Pacific Coast Seattle Indians before being immediately traded to the Wichita Jobbers of the Single-A Western League. Inspired by familiar surroundings—his birthplace was Hiawatha, Kansas—Wilhoit produced the longest hitting streak in all of professional sports by collecting at least one hit in 69 consecutive games.

Local Ventura-area enthusiasm for the game extended to weekly announcements in the local newspapers. Players were guaranteed a minimum payment from gate sales. Teams were also supported by businesses that supplied the uniforms in exchange for advertising space on the jerseys. The White House Dry Goods Store supported a very successful team in Ventura. The Hobson Brothers also bought uniforms for a local squad. Organizations started sponsoring teams, specifically the Knights of Columbus and later the Merchants of each particular city.

High school baseball teams were also very popular local events. Ventura, Santa Paula, and Oxnard all produced proficient ballplayers, but baseball as a profession was less likely a reality for most young men and getting a "real job" much more necessary. Baseball became very much a weekend affair with an occasional barnstorming team stopping off to play a game. The Giants-White Sox exhibition game in Oxnard was a big hit with locals in 1913. Babe Ruth, the greatest slugger of his era, made two visits to Santa Barbara playing against Fred Snodgrass and a congregation of All-Stars from Ventura in 1924 and again in 1927.

In the 1930s, Charles "Red" Barrett and Don Lang left marks on the game. Barrett played for the Simi Valley High team and then in parts of 11 seasons in the majors from 1937 to 1949. Barrett's name was stamped into the record books when he made only 58 pitches in a complete game victory for the Boston Braves in 1944, a record that stands to this day. Lang played his high school ball at Ventura, and by 1938, he made it to the majors, playing one season for Cincinnati in 1938. After decade of minor-league ball and a tour of duty during WWII, Lang returned to the majors for a second season, this time playing for the St. Louis Cardinals in 1948.

After World War II, Ventura became the host city of several major-league affiliates. In 1947, the New York Yankees' Single-A club was added to the California League, which was formed in 1941. The Yankees played their next three seasons at Babe Ruth Field. Anytime the Santa Barbara Dodgers were in town, the 5,000-seat stadium would near its capacity. The Ventura Braves took the Yankees' place in 1950 and played through the 1952 season. The Braves were followed by the independent franchise the Ventura Oilers, and after one season, the team became the Channel Cities Oilers, representing both Ventura and Santa Barbara, after the Dodgers left the more northerly city in 1953. The Oilers vacated two seasons later for Nevada, becoming the Reno Silver Sox. The Ventura County Gulls, affiliated with the Toronto Blue Jays, played the 1986 season at Ventura College. The independent Pacific Gulls then played one embarrassing season at Oxnard College in 1998.

The next round of players from the area to reach the major-league level were Denny Lemaster, Ken McMullen, Jim Colborn, Steve Hovely, Steve Parrott, and Randall Elliott. As the years have progressed, and the population has grown and so has the number of residents who have been selected in the First-Year Player Draft. Ventura County has also produced a major-league Most Valuable Player in Terry Pendleton, who hails from Channel Islands High School and Oxnard College. He was bestowed with the MVP accolade by the National League in 1991 while he playing third base for the pennant-winning Atlanta Braves.

This book is in no way a complete history of baseball in the Ventura County nor is it a list of every professional local player. The successes of the many little leagues, high schools, and college teams deserve a book on their own. This is an informal celebration of baseball professionals linked to Ventura County. Every effort has been made to present accurate names and statistics, and the author apologizes in advance for any errors or omissions.

1

BASEBALL BEGINNINGS

The Ventura Baseball Club of 1885 featured the battery of pitcher Harvey Walbridge and catcher Robert Elwell. Walbridge's services were in such great demand that he was hired by teams up and down the coast to toss the ball. Carl Barkla was the backstop (the position before the modern-day catcher), and the infield consisted of Paul Frost, Fred Corey, Wilmer Akers, and, at third base, John Sebastian. The outfield included John Cawelti, Robert Green, and John Fox. Batters during the era could call for their choice of pitch.

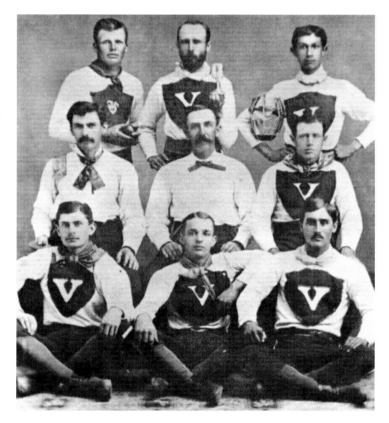

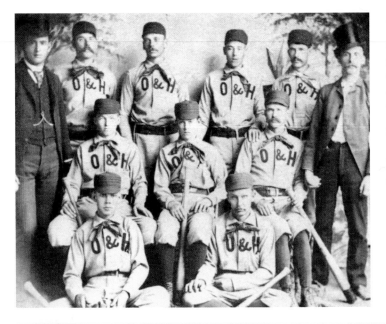

The "O & H" team was organized by Emmet Ord and Charles Haselton with "suits" provided to the players in 1887. Pictured from left to right are the following: (first row) William Nisbit and William Granger; (second row) Arthur Granger, William Fleisher, and Wilmer Akers; (third row) E. G. Ord, Harvey Gallagher, Bob Green, Ike Browne, Dallas Gallagher, and Charles Haselton.

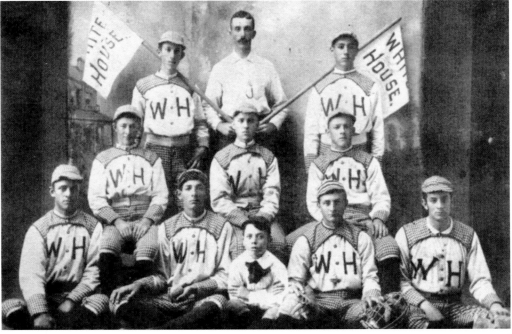

The White House team, organized in 1889, was the frequent opponent of O & H. Sponsored by W. R. Stone, who owned the White House Dry Goods Store in Ventura, the squad included, from left to right, the following: (first row) John Newby, C. Mungari, J. Mitchell, B. Wurch, and Charles Capito; (second row) Walter E. Johnson, P. Haugh, and Ed Newby; (third row) E. Reitzke, A. L. Strickland, and J. Spear. Henry Sparks, who was also on the White House team, kept a continuous journal for 49 years and noted that his Ventura team went undefeated for 12 of those years.

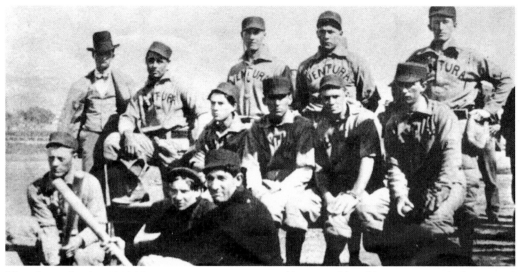

The players for this 1903 Ventura team were sponsored by several local businesses, including Duval Brothers groceries and hardware store; Daly Brothers, which sold "men's furnishings"; and Robbins Brothers Barber Shop. Pictured from left to right are the following: (first row) Henry Sparks, Eddie Hearne, and Cap Mungari; (second row) Bert Brown, Joe Rodriguez, Dan Dixon, and Charlie Mitchell; (back row) manager George Parker, Charlie Kaiser, George Johnson, Johnny Barnett, and Walter Johnson.

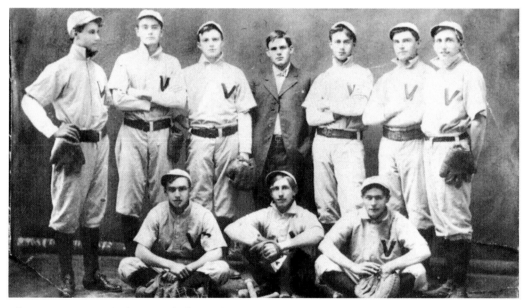

The 1908 Ventura High team challenged not only other high schools but college and independent teams as well. The squad did not lose a single contest from 1904 to 1908. Posing from left to right are the following: (first row) Clarence Argabrite, Bill Ramelli, and Jess Fretwell; (second row) Andrew Sanchez, George Mallory, Harry Peck, Hal V. Hammons, George Sanchez, Harold Dudley, and Walter Argabrite.

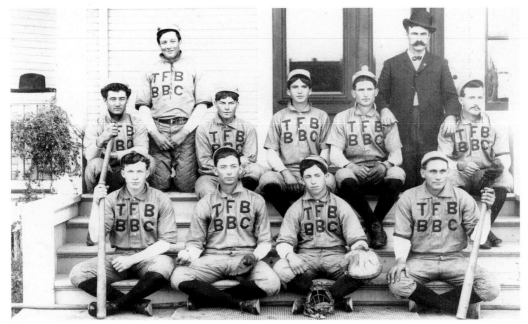

The Springville/Somis team evolved into "The Fraternal Brotherhood of Base Ball Club." The town of Springville faded in the early part of the 1900s, and Camarillo developed into a replacement town. Seen here, in no particular order, are the following: George Stewart, S. Lillie, R. Mahan, Charles Hays, Ed Hays, Charley Gill, Sam Furrer, Andy Cawelti, Charles Covarrubias, Clyde Stewart, and Myron "Spec" Gill. (Courtesy of Bob Gill and Ace Powell.)

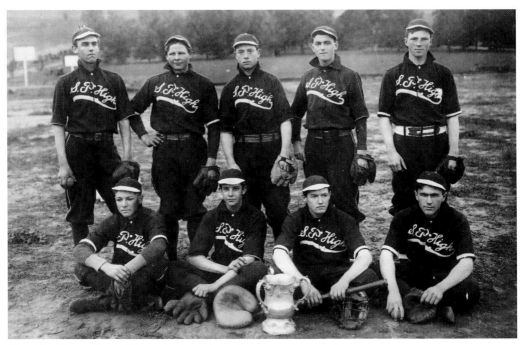

The 1912 Santa Paula Team displays their championship trophy.

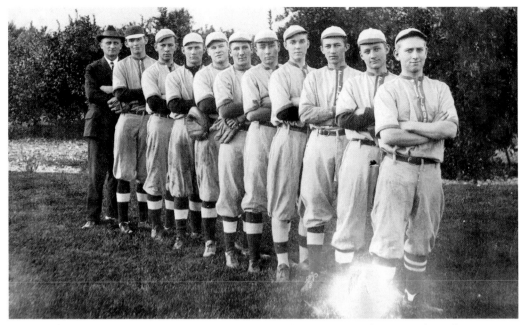

An early Fillmore squad lines up near a citrus orchard. Among the players on the Fillmore teams c. 1910 were catcher C. Browne, pitcher Fred Fairbanks, first baseman Middlesworth, second baseman Basolo, third baseman F. Brown, shortstop Brady, left fielder S. Fairbanks, center fielder Lemmon, and right fielder Colbeck. Fred Fairbanks was one of the most efficient pitchers in the county up through the 1920s. In a game in June 1910, he struck out 15 batters. Other early Fillmore players included teammates Trotter, Howard, and Hutchings.

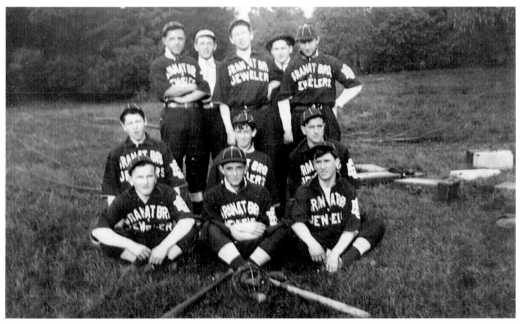

The Granat Brothers Jewelers team is depicted here.

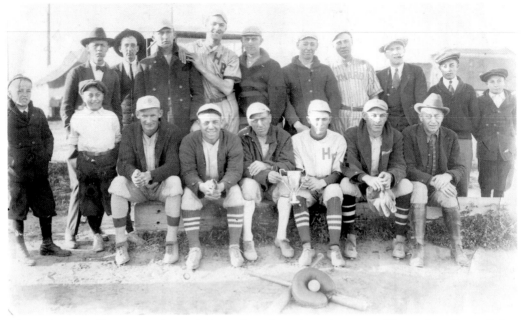

This early 1900 All-Star team featured players from throughout the county. Players from Oxnard's first club, as reported on January 27, 1900, in the *Oxnard Courier*, were Andy Fessler, I. L. McGeary, Ray Snively, C. E. Sebastian, Garner, J. Fulkerson, R. M. Sebastian, Tom McGuire, and Will Stepler.

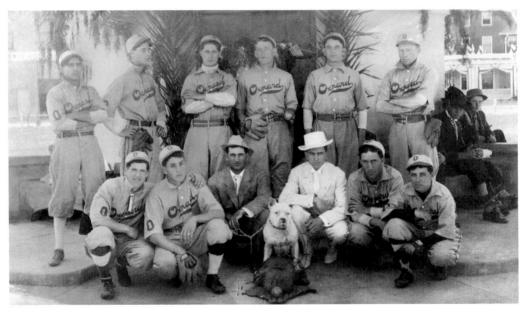

The Oxnard team is seen here as it appeared in 1910 shortly after the Pagoda Bandstand was completed at Plaza Park. In October 1910, the Oxnard Baseball Association was formed and Dr. A. A. Maulhardt was elected president with O. E. Edmonds as secretary treasurer. George Bartlett, Charles Murphy, and John Turbett formed the executive committee, and Turbett took on duties as manager.

A Camarillo ballplayer poses along an unpaved dirt road at what looks to be C Street in Oxnard around 1901.

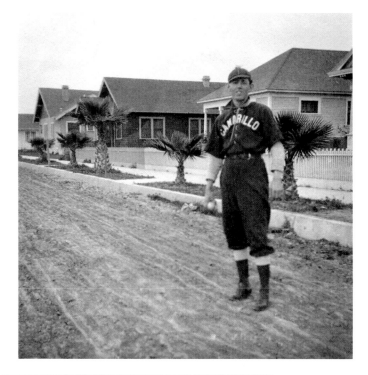

The Oxnard boys show off their latest baseball gear. The boy on the left sports a "Tuff Lions" jersey.

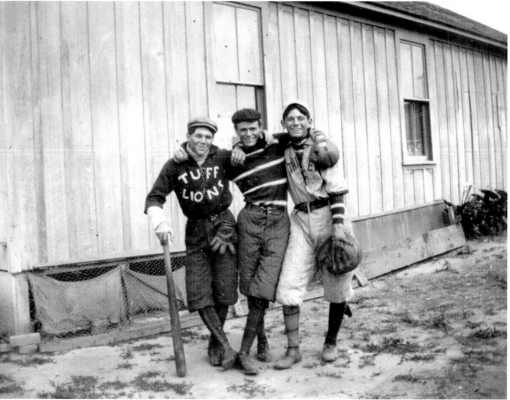

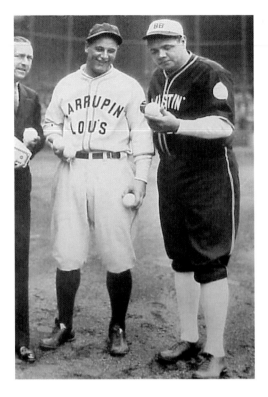

Legend has it that Babe Ruth (right) played in Ventura, yet empirical evidence only brings Ruth as close as Santa Barbara—twice. Ruth's first visit came after the 1924 season, in which he led the American League with a .378 batting average, 46 home runs, and a .739 slugging percentage. Ruth toured with Yankees teammate Bob Meusel, who was also coming off a productive year in which he hit .325. Ruth and Meusel barnstormed after the 1921 World Series, but the two were fined because they violated Section 8B, Article 4 of the Major League Code, which stated that players from the two World Series teams were banned from participating in any other games due to the potential of restaging the World Series in another city. Ruth returned to Santa Barbara in 1927, bringing along Yankees teammate Lou Gehrig (left).

Playing for the Ventura locals was former Giants centerfielder Fred Snodgrass. Pitching against Ruth in the 1924 game was local pitcher Fred Fairbanks. Fairbanks fanned Ruth on three pitches in his first at bat, drawing "boos" from the crowd. Ruth gave the crowd what they wanted in his next at bat, clouting a home run that cleared a row of parked cars beyond the outfield fence. Bob Meusel also smashed a home run.

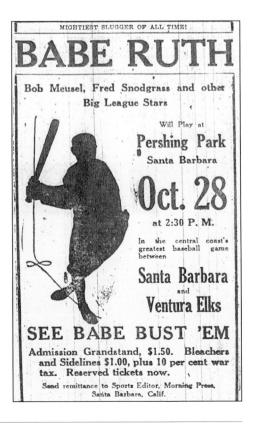

THE GIANTS IN OXNARD

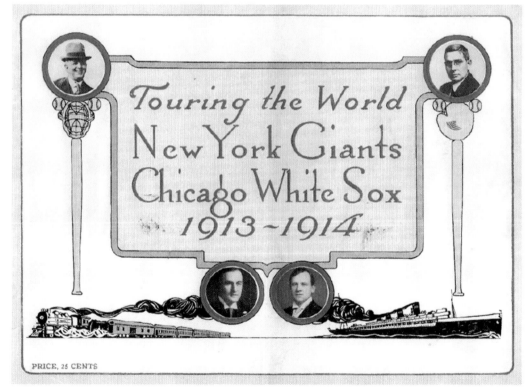

At the conclusion of the 1913 baseball season, John McGraw, the manager of the New York Giants, and Charles Comiskey, owner of the Chicago White Sox, put together a group a major leaguers and toured the Midwest and West Coast before heading off to the Asia and Europe in a series of exhibition games to promote America's pastime. One of the stops was Oxnard, California, home to Giants center fielder Fred Snodgrass.

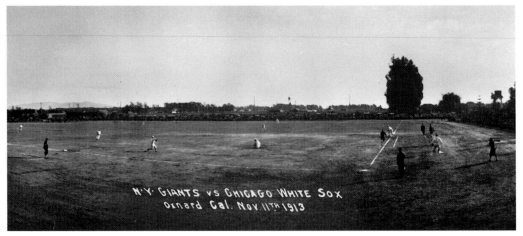

This is a panoramic photograph of the major leaguers' stopover in Oxnard on November 11, 1913. A detailed reconstruction of the day was recorded in the author's self-published book *The Day the New York Giants Came to Oxnard.*

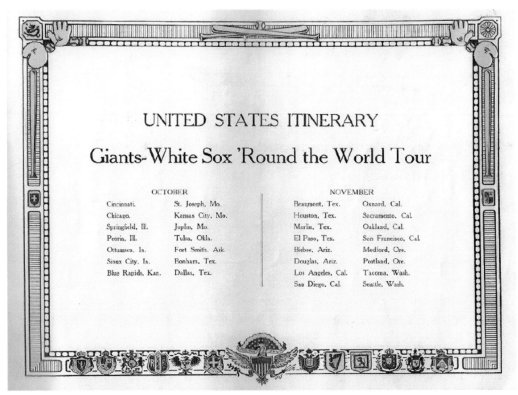

UNITED STATES ITINERARY

Giants-White Sox 'Round the World Tour

OCTOBER		NOVEMBER	
Cincinnati.	St. Joseph, Mo.	Beaumont, Tex.	Oxnard, Cal.
Chicago.	Kansas City, Mo.	Houston, Tex.	Sacramento, Cal.
Springfield, Ill.	Joplin, Mo.	Merlin, Tex.	Oakland, Cal.
Peoria, Ill.	Tulsa, Okla.	El Paso, Tex.	San Francisco, Cal.
Ottumwa, Ia.	Fort Smith, Ark.	Bisbee, Ariz.	Medford, Ore.
Sioux City, Ia.	Bonham, Tex.	Douglas, Ariz.	Portland, Ore.
Blue Rapids, Kan.	Dallas, Tex.	Los Angeles, Cal.	Tacoma, Wash.
		San Diego, Cal.	Seattle, Wash.

This page is from a long out-of-print book titled *World Tour 1913–1914,* published in Chicago by S. Blake Willesden in 1914 and written by touring writers from the *Chicago Tribune.* Fred Snodgrass, "Chief" Meyers, and Christy Mathewson all played in the game in Oxnard. However, all three decided against traveling overseas and were replaced by other major leaguers.

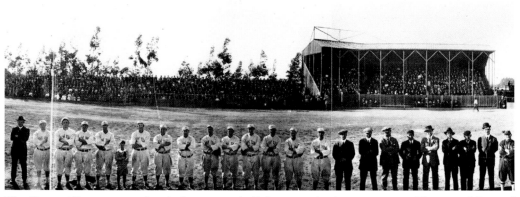

The Oxnard Boasters stand with the touring ballplayers in this historic image. The city of Oxnard spared no expense in hosting the major leaguers. Their new state-of-the-art grandstand boasted additional bleachers, and the city ordered all businesses closed for the Tuesday afternoon game. Schools were suspended for the day while the youngsters enjoyed a once-in-a-lifetime chance to see future Hall of Famers Christy Mathewson, Sam Crawford, and Tris Speaker, along with local hero Fred Snodgrass.

After conquering the West Coast, the tour embarked on the *Empress of Japan* from Victoria, British Columbia, for a series of exhibition games in Tokyo, Shanghai, and Hong Kong. The players autographed the ball used in the game in Manila, Philippines. The final date of the tour was February 26, 1914, in London, England. The players boarded the luxury liner *Lusitania* for their return trip across the ocean.

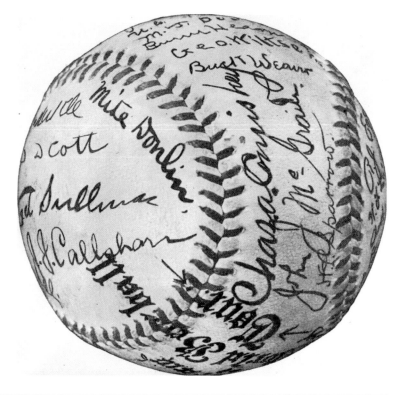

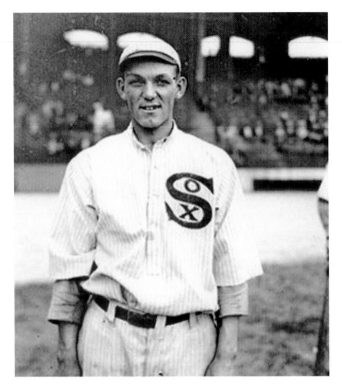

The highly competitive George "Buck" Weaver played shortstop and third base for the Chicago White Sox and was building potential Hall of Fame numbers when he became swept up in the infamous "Black Sox Scandal" of 1919, when members of his team colluded to throw the World Series to the Cincinnati Reds. Weaver had three putouts in the game in Oxnard.

Ray Schalk, the White Sox catcher, also later played in the 1919 Series. Schalk's reputation, however, was never in question, and he was later enshrined in the Baseball Hall of Fame. Schalk was limited to one pinch-hit appearance in Oxnard and dropped out of the tour after a game in Seattle. He was replaced by Ivey Wingo, who traveled with the team on the Oriental and European routes of the tour.

THE GIANTS IN OXNARD

The fan favorite besides local hero Snodgrass was arguably baseball's best pitcher, Christy "Matty" Mathewson. Mathewson was coming off a 25-victory season and had won 30 or more games four times in his career up to that point. As a favor to his center fielder, Mathewson pitched for Snodgrass's hometown, giving up two runs in nine innings and earning the victory.

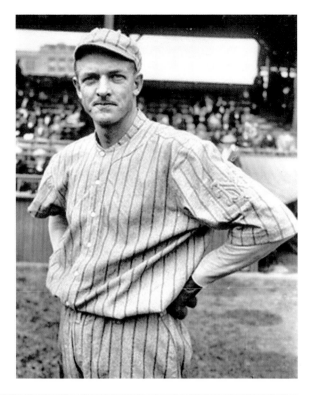

John "Chief" Meyers, the Giants catcher, was born near Riverside, California, and was descended from Cahuilla Indians. He completed the tour in Seattle and came back to Oxnard to play on the local winter-league team with Snodgrass and fellow Giants teammate Art "Tillie" Schafer.

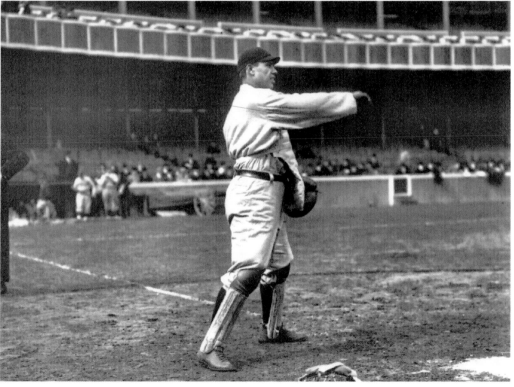

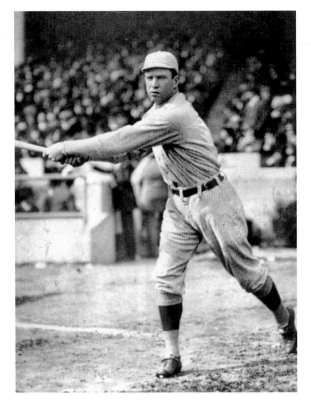

Tristam "Tris" Speaker was an elite hitter and an equally accomplished fielder who completed the 1913 season with the Boston Red Sox. Chicago owner Charles Comiskey invited Speaker on the tour to further guarantee maximum box-office returns. Speaker gathered three hits off Christy Mathewson in a losing effort for the Sox in the game in Oxnard. He went on to play the entire tour up to the final game in London on February 26, 1914. Speaker recorded one of the top-10 best batting averages in baseball history: a .345 mark spanning 22 years.

Sam "Wahoo" Crawford was another non-White Sox player who donned a Chicago uniform for the tour. Crawford played for the Detroit Tigers alongside the much-despised batting legend, Ty Cobb. Crawford rivaled Cobb's power and speed but not Cobb's personality. Crawford was yet another future Hall of Famer, and he displayed his power in Oxnard by knocking a ball over the row of automobiles lining the outfield for the game's only home run. Crawford's combination of power and speed helped him set the major-league mark for most triples in a career, 312.

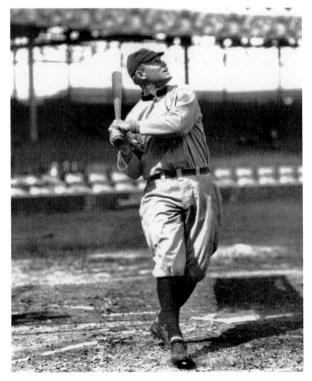

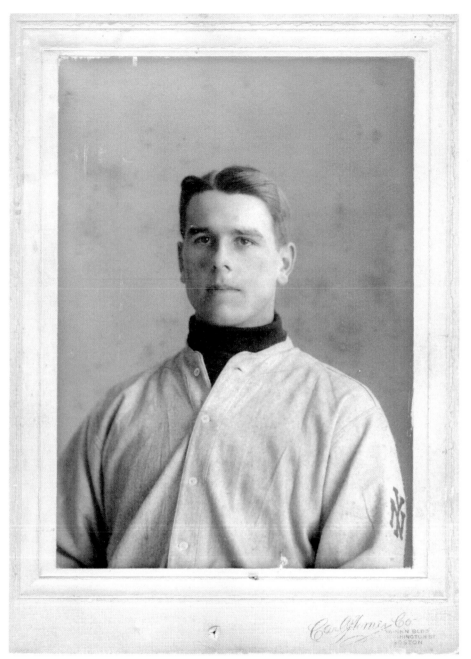

Fred Snodgrass signed with the Giants in 1908 and soon after purchased a ranch near Oxnard in the El Rio area. After competing for the batting title in 1910, Snodgrass helped the Giants reach the World Series the next three years. It was in 1912 when he made the infamous error that contributed to the team's loss to the Red Sox in the final game. He muffed a routine fly ball that was hit to him in center field in the 10th inning of the series' final game, opening the door for a Boston world championship. Yet the forgiving and appreciative fans in Oxnard presented Snodgrass with at gold watch at the game in Oxnard in 1913.

LARRY DOYLE
New York Giants
Captain and 2nd Base

GEO. WILTSE
New York Giants
Pitcher

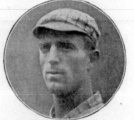

FRED MERKLE
New York Giants
1st Base

MIKE DONLIN
New York Giants
Center Field

JOHN McGRAW
Manager New York Giants

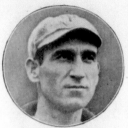

MIKE DOOLAN
Philadelphia N. L.
Short Stop

LEE MAGEE
St. Louis Cardinals
Left Field

JIM THORPE
New York Giants
Right Field

HONUS LOBERT
Philadelphia N. L.
3rd Base

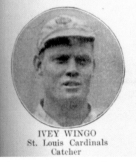

IVEY WINGO
St. Louis Cardinals
Catcher

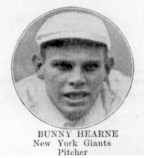

BUNNY HEARNE
New York Giants
Pitcher

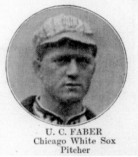

U. C. FABER
Chicago White Sox
Pitcher

The Giants roster changed as the tour progressed. The lineup for this photograph represented a later version of the team overseas. Jim Thorpe was on his honeymoon and missed the game in Oxnard but joined the team for the remainder of the tour. Fred Merkle was another Giants player labeled a "goat" by the press for a costly base-running error during the 1908 pennant race. Despite the unfair characterization, Merkle went on to have a respectable career that spanned 16 years with five World Series appearances.

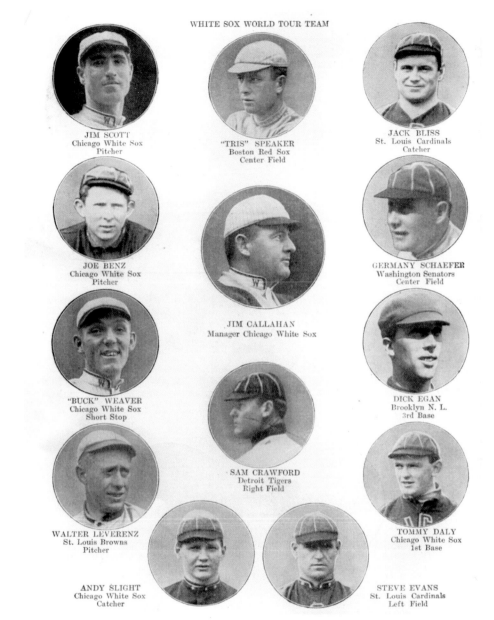

WHITE SOX WORLD TOUR TEAM

JIM SCOTT
Chicago White Sox
Pitcher

"TRIS" SPEAKER
Boston Red Sox
Center Field

JACK BLISS
St. Louis Cardinals
Catcher

JOE BENZ
Chicago White Sox
Pitcher

GERMANY SCHAEFER
Washington Senators
Center Field

JIM CALLAHAN
Manager Chicago White Sox

"BUCK" WEAVER
Chicago White Sox
Short Stop

DICK EGAN
Brooklyn N. L.
3rd Base

SAM CRAWFORD
Detroit Tigers
Right Field

WALTER LEVERENZ
St. Louis Browns
Pitcher

TOMMY DALY
Chicago White Sox
1st Base

ANDY SLIGHT
Chicago White Sox
Catcher

STEVE EVANS
St. Louis Cardinals
Left Field

The White Sox squad also saw changes after the Oxnard game. One player who played in Oxnard and was a welcome addition for the remainder of the tour was Herman "Germany" Schafer. A member of the Washington Senators, he was invited along for his comedic relief. Schaefer's antics helped change one of baseball's rules when he "stole first base" after having successfully stolen second base during a double-steal attempt to get another runner from third to home. In an effort to get the catcher to throw to second, Schaefer ran back to first, then re-stole second, each time releasing a "blood curdling shout" to get the catcher's attention. His second attempt to steal second resulted in a throw by the catcher and the successful bolt across the plate by the runner on third. A rule later was issued disallowing any runner from returning to a previous base.

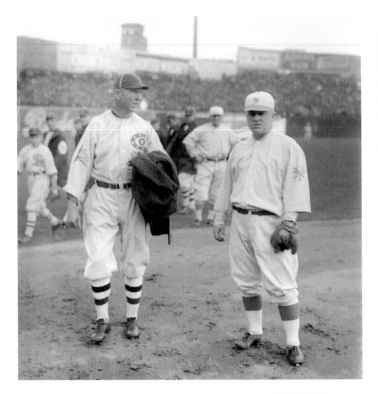

Joe "Blitzen" Benz (left) pitched for the White Sox and earned his nickname for his blazing fastball, which inspired the naming of a race car. Unfortunately, Benz's fastball was as erratic as it was fast. Benz took the mound in the Oxnard game, giving up 12 hits, much to the delight to the Giants-biased crowd. John McGraw (right), the manager and part owner of the New York Giants, had already managed in four World Series by the time of the Oxnard game.

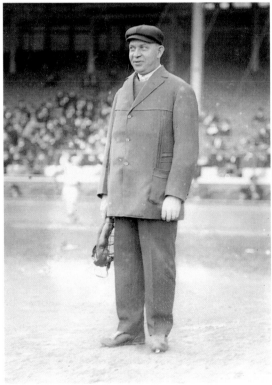

Hall of Famer Bill Klem was one of two umpires on the world tour (the other was Jack Sheridan) and one of McGraw's most reviled nemeses. American League president Ban Johnson was on the committee that selected Klem for the tour and had been another of McGraw's enemies ever since the autocratic McGraw refused to allow the National League champion Giants to play the American League champion White Sox in a deciding World Series in 1904, thus cancelling the second World Series championship game.

THE GIANTS IN OXNARD

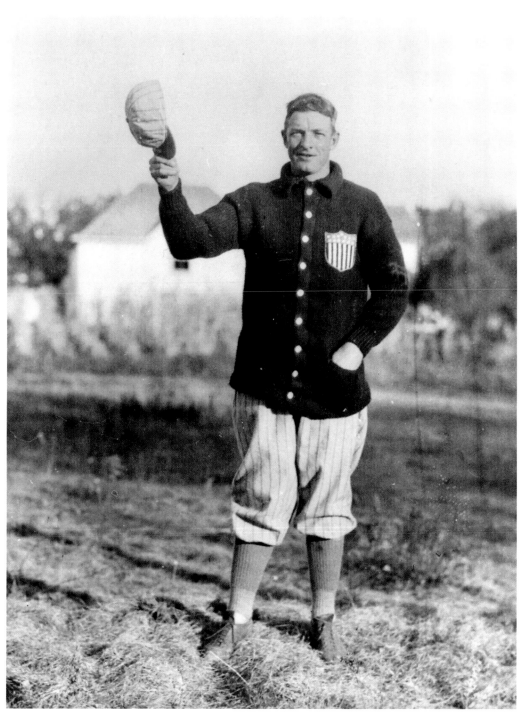

Christy Mathewson sports the Giants world tour uniform with its blue pinstripes, blue knit sweater with a patriotic shield taken from the previous year's Olympics, and a hat with the same shield. The White Sox wore dark blue uniforms, white socks with a blue stripe, and a set of flags on the sleeves.

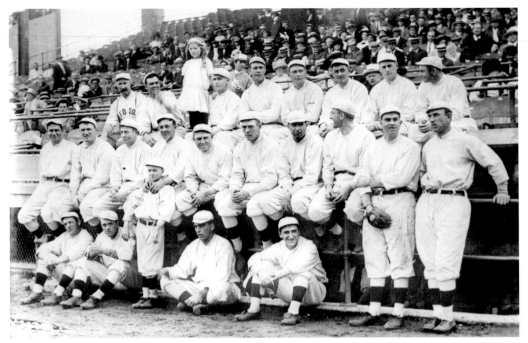

The American League champion Boston Red Sox finally got a chance to face the Giants in the 1912 World Series. Playing for the Red Sox was Ventura native Charley Hall (middle row, fourth from the right). This was the World Series in which Snodgrass got the label of "goat," although a thorough examination of the final game more than shows that he wasn't the only Giant who contributed to the final-game loss in the 10th inning.

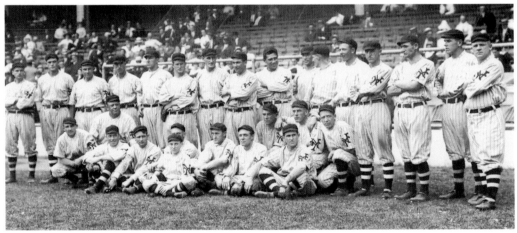

The 1913 Giants won their third consecutive National League championship and lost their third consecutive World Series, the second of those in 1912 to Connie Mack's Philadelphia Athletics. Posing on the Giants team, Snodgrass is standing, second from the right, with "Chief" Meyers eighth from the right, and Art Shafer at the far left. All three played for the Oxnard winter team. Also included in the back row are Mathewson, fifth from the right, and Fred Merkle, fourth from the right.

THE GIANTS IN OXNARD

BOSTONS WIN IN TENTH AND ARE WORLD'S CHAMPS

New York Giants Finally Beaten, in Sensational Finish 3-2

Snodgrass Makes Fatal Muff Which Allows Red Sox to Get Over Winning Run

The October 17, 1912, *Philadelphia Inquirer* ran the headline labeling the Snodgrass error a "fatal muff." Snodgrass himself admitted through the years that he should have made the catch, though Tris Speaker of the Red Sox claimed the fly ball was much more than a routine play. When asked about the error by locals, Snodgrass invariably replied, "If it wasn't for that darn error, nobody would know who I was." The older, wiser, and modest Snodgrass made a name for himself as a first-class citizen. He served as mayor of Oxnard in 1937.

The Giants, after two World Series losses in a row, had a chance to redeem themselves in the 1913 World Series, right before the world tour. But the Athletics played superbly, led by Frank "Home Run" Baker, who hit a major-league record of 12 home runs in 1913. The Athletics beat the Giants for the second time in three years. The program for the 1913 World Series shows McGraw being congratulated by a patriot from the "city of brotherly love" for winning five National League championships in 10 years.

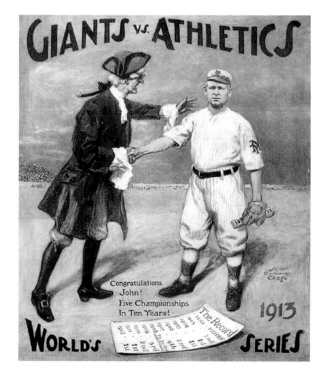

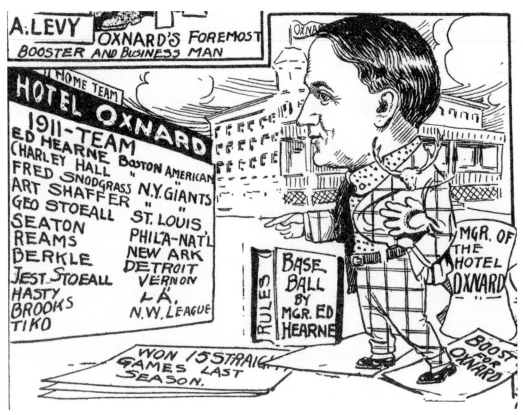

This caricature of Ed Hearne appeared in the May 1912 edition of *Out West* and later was reproduced in the *Ventura County Quarterly*. Hearne's wife's aunt, Etta Willis, owned the Oxnard Hotel that Ed managed. Hearne also played briefly with the Boston Red Sox in 1910—two games as shortstop. He also helped put together the Oxnard's All-Star winter club, which included several major leaguers, such as the Giants' Art Shafer, the St. Louis Browns' George Stovall, and the Phillies' Tom Seaton.

This was one of the many 1913 cartoons suggesting that the world tour was out to "save" baseball. The game certainly woke up the locals. With a population of 2,500, the crowd for the Oxnard game nearly doubled the size of the city with more than 4,500 people in attendance.

THE GIANTS IN OXNARD

George Stovall, along with his brother Jess, played several seasons with the Oxnard winter club. George began his career with the Cleveland Indians in 1904, and by 1912 was playing for the St. Louis Browns. In 1914, he tried his luck with the Kansas City Packers in the ill-fated Federal League. Stovall was a solid .270 hitter for most of his 12-year career. He was also witness to Herman Schaefer's stealing of first base; a first baseman, Stovall was so caught off guard that he did not even cover the base.

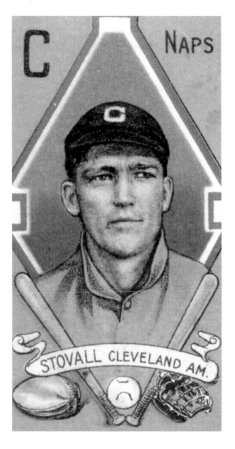

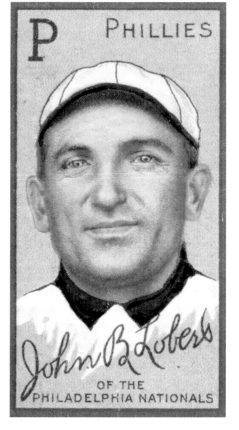

John Hans Lobert accompanied the New York Giants on the world tour even though he was with the Philadelphia Phillies. He concluded a 14-year career with the Giants in 1917. Lobert was one of baseball's swiftest base runners. Oxnard mayor Joe Sailer once suggested that Lobert race against the county's top horseman, Panfilio Lorenzana, and his cow pony. Reluctantly, Lobert took on the challenge and told author Lawrence Ritter, "The horse won by a nose." Citing his own large muzzle, Lobert added, "But as you can plainly see, that was unlikely."

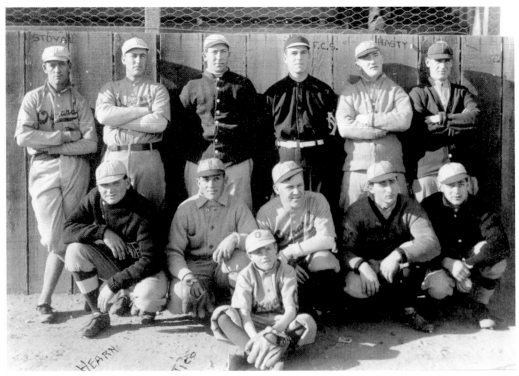

The 1911 Oxnard team included several big leaguers. Pictured from left to right are the following: (front row) Ed "Red" Hearn (shortstop), Harry Tico (left field), ? Berkel, ? Miller (right field), ? Brooks, and Tiny Slaughter (mascot); (second row) George Stovall (first base), Babe Reams (second base), Tom Seaton (pitcher), Fred Snodgrass (third base), ? Hasty (catcher), and ? Bacom (center field). Tico played in the Northwestern League for a brief period. Jess Stovall, brother of George, pitched a year each with Cleveland in 1903 and Detroit in 1904 and later served as a major-league scout.

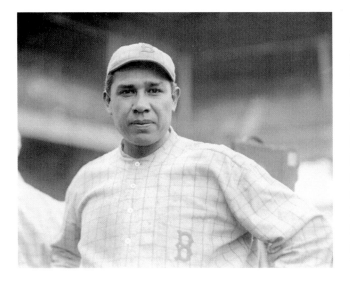

A 28-year-old rookie for the Giants in 1909, John "Chief" Meyers's proficiency behind the plate hastened Snodgrass's switch from catcher to the outfield, underscored by McGraw's wish to better utilize Snodgrass's speed. Meyers had a .291 career batting average, with a team-best .358 mark in 1912. He went on to play for the Brooklyn Dodgers in 1916 and completed his career in 1917 with the Boston Braves.

THE GIANTS IN OXNARD

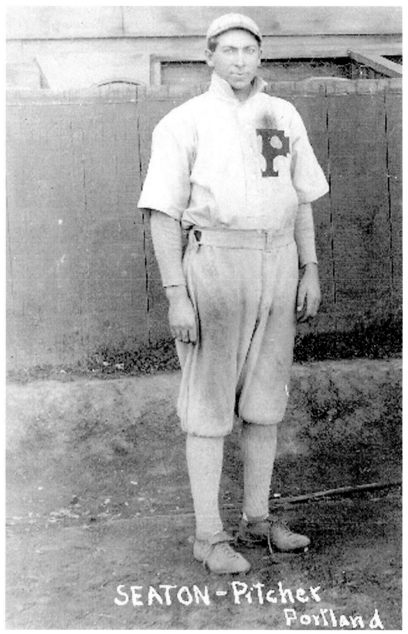

SEATON – Pitcher
Portland

Tom Seaton pitched for the Oxnard winter team in 1911. He was a knuckleballer who began his career with the Portland Beavers of the Pacific Coast League in 1909. In 1912, Seaton signed with the Philadelphia Phillies. He pitched six professional seasons in the majors from 1912 to 1917. His best season was 1913, when he led the majors with 27 victories for the Phillies, followed in 1914 by 25 wins for the Brooklyn Tip Tops of the short-lived Federal League. He returned to the National League with the Chicago Cubs for two years before ending his career in the Pacific Coast League. Seaton's career ended in controversy. He was barred from the Pacific Coast League for being a "known gambler." Seaton was also accused of using an emery board while pitching.

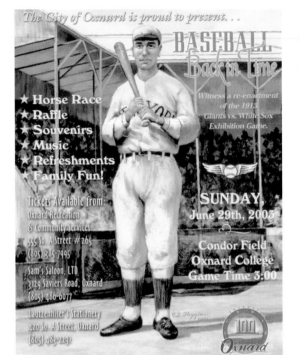

In 2002, for the centennial birthday of Oxnard, a committee was formed by Gil Ramirez of the Oxnard Parks and Recreation Department to re-create the Giants-White Sox game that so enthralled the city in 1913. Frank Boross and Chris Higgins were hired to take charge of the graphics for the event, and the Snodgrass poster created by the two captured the essence of the event. Boross and Higgens applied the same authenticity in creating a program, tickets, and replica "tobacco" cards for the successful event.

One of the benefits of being a ballplayer in 1913 was a barbecue at the Perkins house, which included roasted ox head, tri-tip cuts, lima beans with onions, and warm beer. The 2003 event was re-created at the relocated Perkins House at Heritage Square on A Street in Oxnard, sans the ox head and beer. Spencer Garrett, the grandson of Fred Snodgrass, is seen here addressing the crowd and sharing an amusing story about his grandfather. Other notables at the barbecue and game were the Thomas Oxnard family and James Elfers, the author of *The Tour to End all Tours*, a comprehensive book about the White Sox-Giants tour.

THE GIANTS IN OXNARD

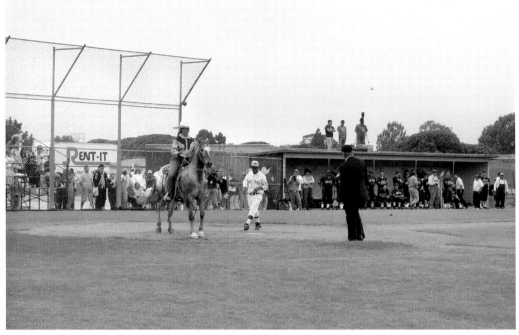

No re-creation of the original event could be without the crowning event of the original day, the horse race between man and beast. This time, Oxnard College and Hans Lobert impersonator Michel Lara donned the cleats and Tina Frost Donatelli took the place of the mounted Panfilio Lorenzana.

This time, the outcome did not need a nose to know who won, as the cleated Lara won by several noses. The game also had a different outcome, as the new version of the White Sox defeated the Giant All-Stars, 6-2.

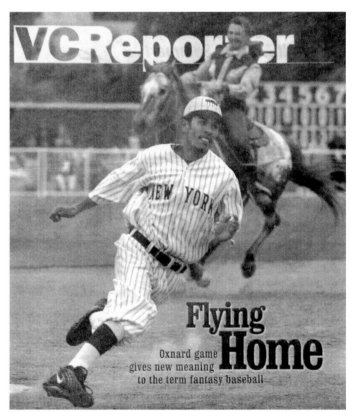

VCReporter

Flying Home

Oxnard game gives new meaning to the term fantasy baseball

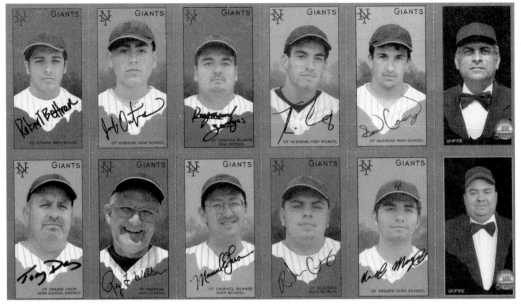

Boross and Higgins faithfully replicated the old 1909–1911 T-205 tobacco cards with pictures of the current players and coaches. Pictured from left to right are the following: (top row) players Robert Beltran, Jacob Ontiveros, Ray Zendejas, Tim Casey, and Sean Casey, and umpire Tony Hernandez; (bottom row) coaches Tony Diaz, Reg Welker, and Manny Lara, players Ruben Cruz and Nick Magana, and umpire Tony Gazzera.

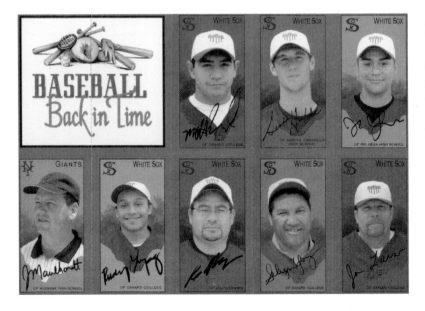

Partaking in the 1913 game re-creation were, from left to right, the following: (top row) players Matt Bernal, Scott Holder, and J. R. Leon; (bottom row) author Jeffrey Maulhardt, player Rudy Lopez, and coaches Ramiro Mares, Selwyn Young, and Jon Larson.

THE GIANTS IN OXNARD

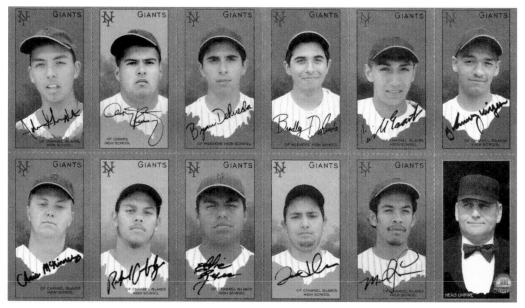

Also part of the game were, from left to right, the following: (top row) players Adam Gonzales, Anthony Ramirez, Bryan DeRueda, Bradley DeRueda, Cirilo Esquita, and Johnny Virgen; (bottom row) Chris McKinney, Richard Cambaliza, Eddie Reyes, Jose D. Hernandez, Michel Lara, and umpire Russ Stevens.

Portraying the White Sox in the re-creation were, from left to right, the following: (top row) players Greg Magley, Chad May, Andrew Garcia, Brian Mauricio, and Andrew Brewer; (bottom row) Steve De Fratus, Mike Astorino, Julio Aguilera, Zac Haines, and Joseph Navarro.

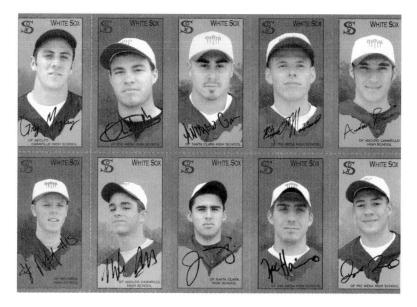

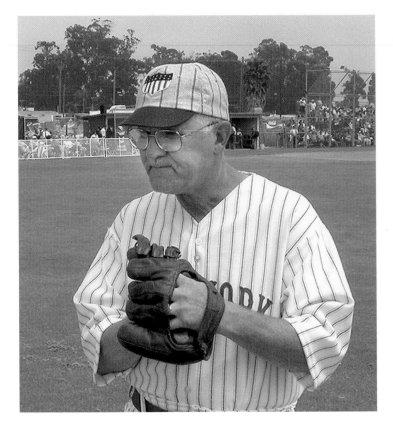

Longtime Hueneme Vikings coach Reg Welker, sporting a Giants uniform, tries on an authentic replica of the mitt players once used for the game. The bats were also copied from those from the era of the original game. The baseball committee brought in designer Holley Gene Leffler to work with the public in re-creating 1910-era clothing.

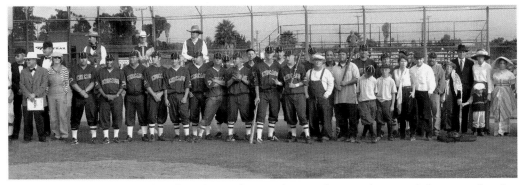

The players and the crowd gathered near home plate at the conclusion of the game for this panoramic photograph.

THE GIANTS IN OXNARD

LOCAL TEAMS

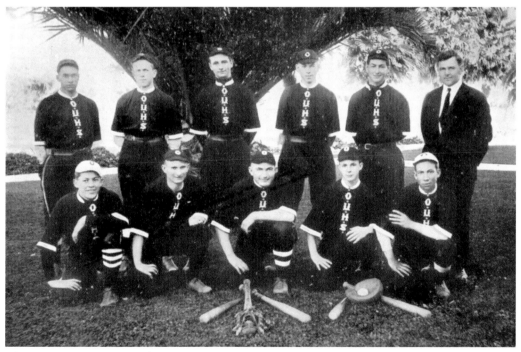

The 1915 Oxnard team was the best in the school's young history. The team included Andy Lillie, Detlef Joehnck, Bennie Schmitz, "Tube" Teubner, "Hum" Hummel, Jess Smith, Rex Sawyer, Marion Pitts, Leneal Wood, and Calvin Glenn.

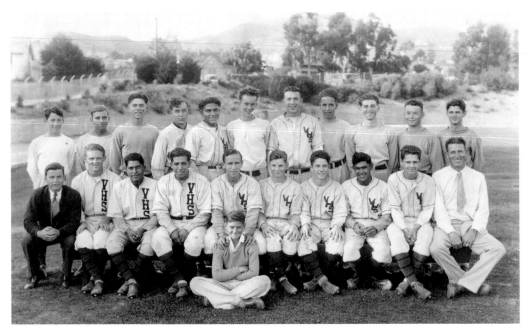

A Ventura High team photograph in the early 1930s depicts here, from left to right, the following: (seated) Pete Wigton; (first row) Don Burum, Bill Dysart, Herminio Cobos, Juan Garcia, Clyde Wooley, Don Lang, Ray Faulk, Bill Flores, Kenneth Nugent, and coach Kolberg; (second row) Albert Barnes, Jack Wigton, Harold Holub, Harlan Lamp, Juan Macias, Norman Morrison, Walter Poplin, Bill Chaffee, Harold Kingston, Bob Sorem, and Wesley Fraser.

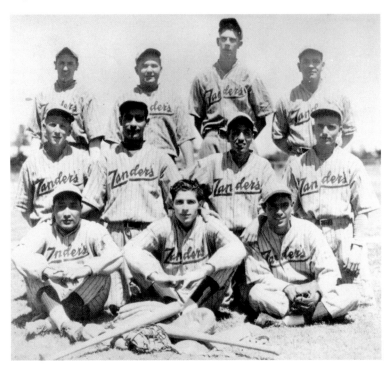

Pictured here is another All-Star group from Ventura in the 1930s. Posing from left to right are the following: (first row) Marty Flores, Sal "LoLo" Gonzalez, and Bill Flores; (second row) Peters, Phil Marquez, Joe Lorenzana, and Jack Wigton; (third row) Art Lillie, Chuck McIntire, Ellsworth Suytar, and Cephas Gonzalez.

LOCAL TEAMS

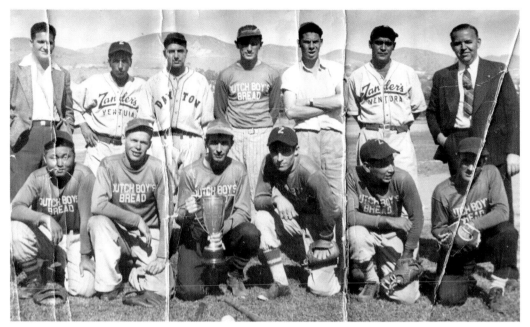

The 1934 Ventura County champions included many former Ventura High players. Seen here from left to right are the following: (first row) Chick Suzuki, "Harvey," LoLo Gonzalez, Eddie Griego, unidentified, Paul ?; (second row) Keith Coffey, John Lorenzana, Jack Wigton, unidentified, Junior Suytar, Phil Marquez, and unidentified.

As softball began to grow in popularity, the old Ventura guys kept on their cleats to take on all comers. The Ventura Knights of Columbus sponsored the 1948 "Heinies." Pictured from left to right are the following: (first row) Dick Lang, Johnny Moss, Jack Lang, Don Sloniker, and batboy Butch Griego; (second row) Phil Marquez, Ed Griego, Gene Brooks, Bob Henry, Dalt Clements, Marian Amescua, and Ted Venegas.

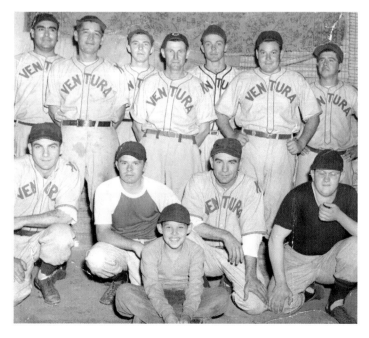

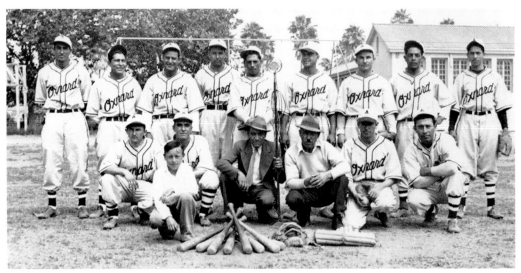

The Oxnard Aces played on the Oxnard Athletic Field at Haydock School in the 1930s and 1940s. The field was the same one that the Giants and White Sox played on in 1913 and was located near Wooley Road and E Street.

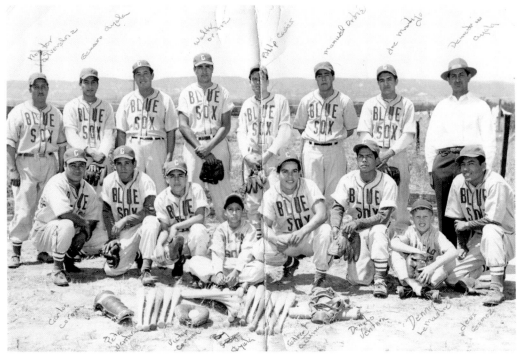

The Camarillo Blue Sox also played during the 1930s and 1940s. The team included, from left to right, the following: (first row) Carlos Corona, Pete Ventura, Victor Corona, Louie Ayala, Gilbert Acuna, Donato Ventura, future major leaguer and batboy Denny Lemaster, and Jess Gomez; (second row) Nester Alvarez, Genaro Ayala, unidentified, Wolf Ortiz, Philip Casa, Manuel Ortiz, Joe Montoya, and Demetrio Ayala.

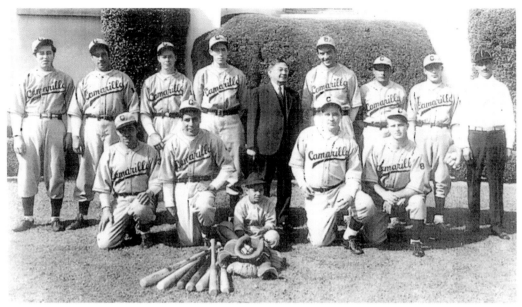

The Camarillo team poses in front of the Pleasant Valley School along with their team sponsor, Aldofo Camarillo, around 1940.

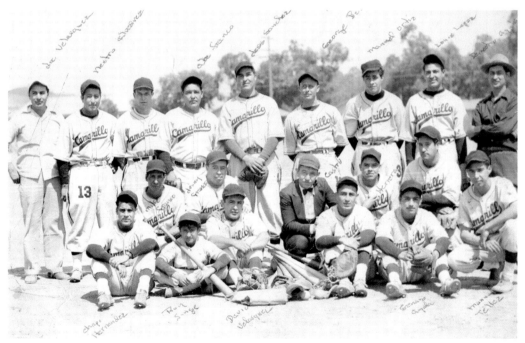

The c. 1950 Camarillo Merchants were a mix of Blue Sox players and Merchants players. Posing here from left to right are the following: (first row) Chapo Hernandez, Ron Singh, David Velasquez, unidentified, Genaro Ayala, and Manuel Tellez; (second row) Mike Franco, Johnny Franco, umpire ? Castro, ? Herrera, and unidentified; (third row) Joe Velasquez, Nestro Alvarez, unidentified, Abe Franco, Jess Sanchez, George Bell, Manuel Ortiz, Louie Lopez, and Demetrio Ayala.

"Peppery" second baseman Jerry White batted .356 for the 1954 Oxnard Yellow Jackets. His 50-plus years in baseball were spent at Fresno State University, Hueneme High School, and Oxnard College. White's success as a baseball player and mentor landed him a spot in three Halls of Fame: Fresno State, Ventura County, and California Community College Halls of Fame.

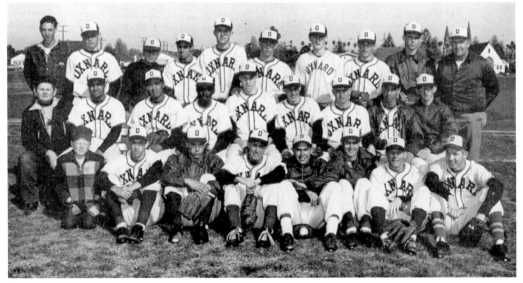

The 1953 Oxnard High team won the Ventura County League title with an undefeated season. The champions from left to right are the following: (first row) batboy Williams, Cain, Hernandez, Reich, Escalante, Hunter, McNabb, and Underwood; (second row) team manager Fogo, Valles, Villa, Hughes, Staniland, White, Kershaw, Walker, and Daniels; (third row) team manager Ranger, Reser, Castro, Valles, Heath, Morr, Eads, Core, Venable, and head coach Killingsworth.

LOCAL TEAMS

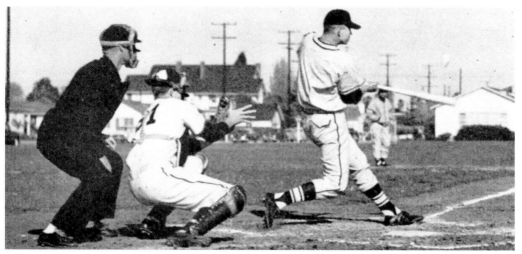

Catcher Charles "Buster" Staniland led the undefeated Oxnard Yellow Jackets with a .408 batting average in 1953. He signed with the St. Louis Cardinals organization and played professionally for 13 seasons. Staniland has passed on his knowledge of the game to many young ballplayers who have since risen to the major-league level. He has coached for nine successful seasons at Oxnard College.

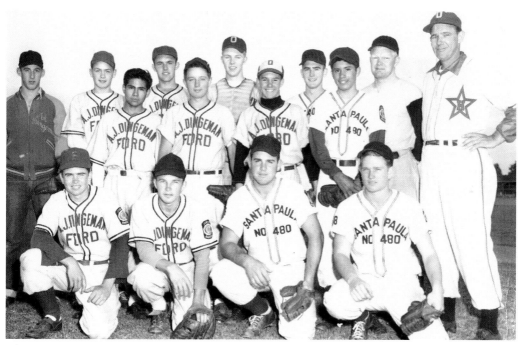

The 1952 American Legion All-Stars featured players from both Santa Paula and Oxnard. The team included, from left to right, the following: (first row) Joe Kershaw, Jim Cone, and two unidentified players; (second row) Tony Rodriguez, Bob Pearmone, Jerry White, and Benjie Osuna; (third row) Bill Keher, Jim Reser, Hugh Heath, Charles "Buster" Staniland, Pat Platt, coach Johnny Burleson, and coach Harper White.

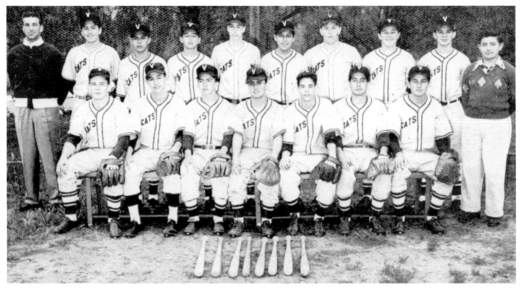

The 1952 Villanova baseball team put together their best season in 30 years. Pictured here from left to right are the following: (first row) M. Fitzgerald, J. Gallego, F. Torres, L. Orrantia, R. Ensch, C. Hadlow, and B. Berg; (second row) coach Bob Urbani, O. Torres, A. Olivas, A. Moreno, C. Edwards, A. Ruiz, J. Bunning, G. Martinez, V. Gomez, and J. Inzalaco.

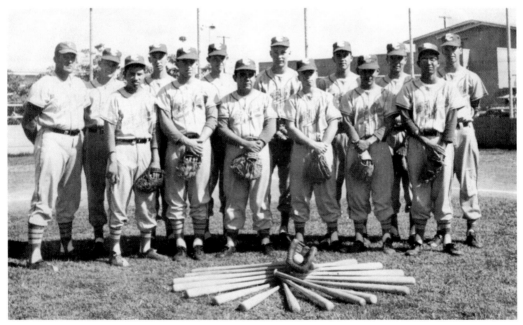

The Santa Clara High School team went 18-0 in 1960 under the tutelage of the legendary Lou "Coach C" Cvijanovich. The team included, from left to right, the following: (first row) Chris Gutierrez, Denny Gherini, Larry Ayala, Dave Laubacher, Dick Jaquez, and Pete Gutierrez; (second row) "Coach C," John Hanson, Tom Gill, Steve Miller, Jerry Vinson, John Schott, Dick Chaparro, and John McCarthy.

LOCAL TEAMS

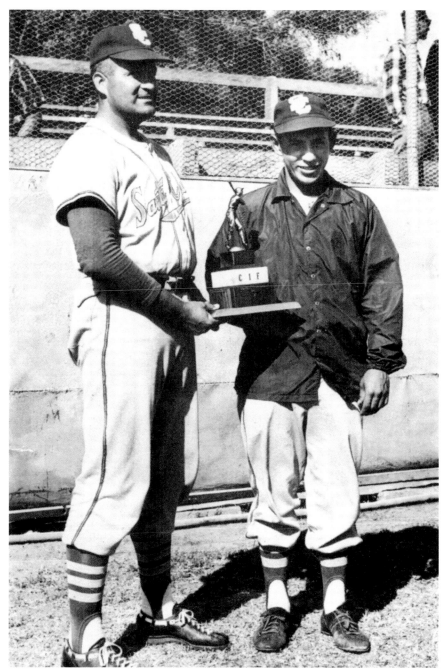

The Santa Clara High School team had five All-League representatives, including Steve Miller, Dave Laubacher, Denny Gherini, Larry Ayala, and All-League Most Valuable Player Dick Jaquez, pictured here (right) with the Coach of the Year Lou Cvijanovich. Jaquez was 11-0 with a 0.37 ERA. He went on to play for the Houston Colt 45s rookie-league team in 1964. Cvijanovich went on to win 114 games as a varsity baseball coach, 104 games as the football coach, and 829 games as the basketball coach, including three state championships.

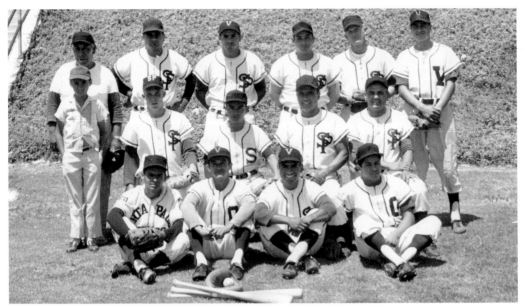

These are the 1961 Ventura County Merchants from Santa Paula. Posing here from left to right are the following: (first row) Tiny Tipton, Ernie Alamillo, Eddie Carlos, and John Ramirez; (second row) batboy Bob Flores Jr., Jim Colborn, Ray Duran, Tony Vasquez, and Sam Marquez; (third row) manager Tony Rivera, Albert Mendoza, Bob Flores, Ben Osuna, Phil Woods, and Ray Flores.

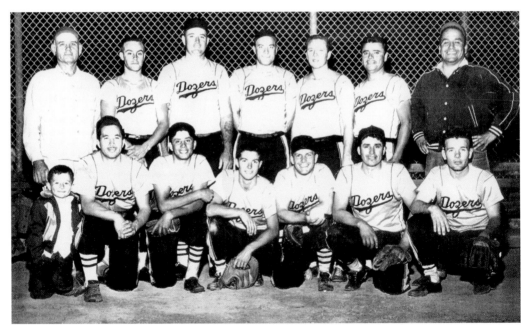

The Dozers team, c. 1950s, was sponsored by Bob Bianci and Chet Wycoff. Pictured from left to right are the following: (first row) Willie Martinez, Barney Martinez, Ben Osuna, Charlie Jones, Olie Caputo, Hank Osuna, and Norris Fletcher; (second row) Pappy Newman, Jackie Newman, Bud Pena, Jack Burdullis, Buz Needham, Tony Vazquez, and Ted Mendoza.

LOCAL TEAMS

Donald Lang graduated from Ventura High School in 1930, then from Ventura Junior College, and played in 1935 for the Los Angeles Angels of the Pacific Coast League. In 1938, Lang played 21 games for the Cincinnati Reds. He was traded to the New York Yankees organization in 1940, and in 1942, the Boston Red Sox acquired him. He returned from service in World War II in 1946 to the St. Louis Cardinals organization, for whom, in 1948, he played 110 games, batting .269 between Stan Musial and Enos Slaughter in the lineup. Lang played a final year in 1950 for the San Francisco Seals.

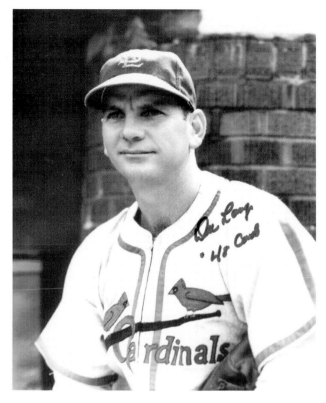

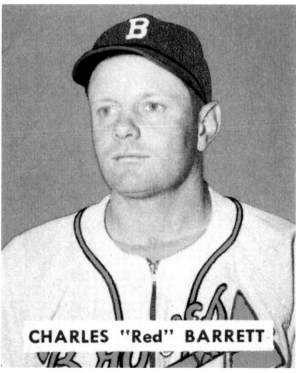

CHARLES "Red" BARRETT

Charles "Red" Barrett graduated from Simi Valley High School and joined the Chicago Cubs organization. In 1937, his contract was purchased by the Reds, for whom he made his debut on September 15, 1937, pitching six and one-third innings and allowing only one earned run. In four years with the Reds, Barrett won three games. Barrett's best year was 1945 when he led the league with 23 wins, with 2 for the Boston Braves and 21 for the St. Louis Cardinals. He pitched the shortest night game in baseball history on August 10, 1944, at Crosley Field in Cincinnati—one hour and 15 minutes—hurling a shutout and a major league–record low of 58 pitches while giving up only two hits.

Southpaw Gary James is recognized as one of the two best pitchers to come out of Channel Islands High School in Oxnard; the other being Ernie Carrasco. After establishing the school record for most victories, the left-hander was drafted by the Chicago Cubs in the third round of the 1969 draft.

Ernest Carrasco III followed in his father's footsteps as an exceptional athlete. Ernest II played for the 1959 Oxnard High team that included future Dodger Ken McMullen. One of Ernest Carrasco III's teammates at Channel Island High School was future National League Most Valuable Player (in 1991) Terry Pendleton. The 6-foot, 4-inch Carrasco dominated the Frontier League in his two years as a starting pitcher, posting a 23-1 record.

LOCAL TEAMS

Don Cardinal was voted into the Ventura County Sports Hall of Fame in 1993 after a 431-220 record as varsity coach for Channel Islands High School from 1967 to 1992, making him the winningest baseball coach in county history. Cardinal coached many major-league prospects, including Gary James, Steve Loiselle, Don Hariston, Chest Franklin, Terry Pendleton, John Johnson, Angel Aragon, and Ernie Carrasco III.

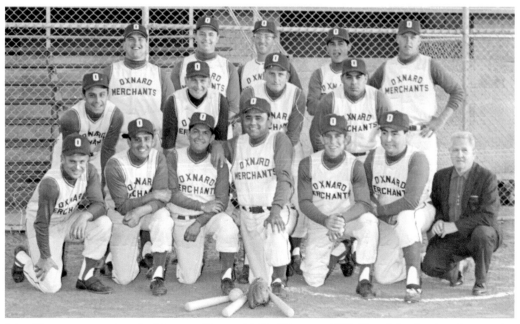

John Flores was voted to the Ventura County Hall of Fame in 1993. Here John lends a glove to the 1964 Oxnard Merchants, including Santa Paula and Oxnard players. Pictured from left to right are the following: (first row) Chuck Stovall, Ben Osuna, Eddie Cobos, Tony Vasquez, Bill Haney, John Flores, and manager Ted Blackwell; (second row) Jackie Newman, Bob Henry, Jerry Willard, and Bob Flores; (third row) George Kinder, Bob Bullock, Jim Daniels, Ray Flores, and Bud Newman.

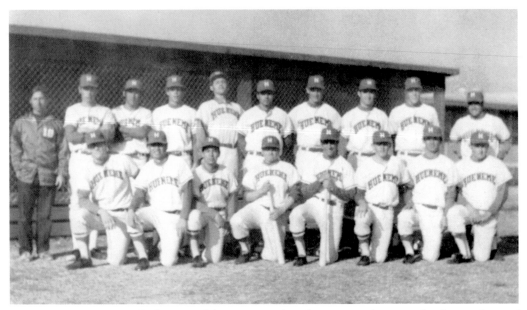

The Hueneme High baseball teams of the 1970s produced many top players under the coaching of Jerry White. The 1971 team included, from left to right, the following: (first row) Jim McDonald, Ronnie Martinez, Ray Gallo, Albert Peraza, Randy Marple, Bob Rydalch, Willie McIntyre, and George Carnes; (second row) manager Don Hatland, Curt Lewis, Ralph Mendoza, Craig Wooten, Carl Pinkard, Danny Garcia, Joe Davis, Danny Marple, Barry Wooford, and coach Jerry White.

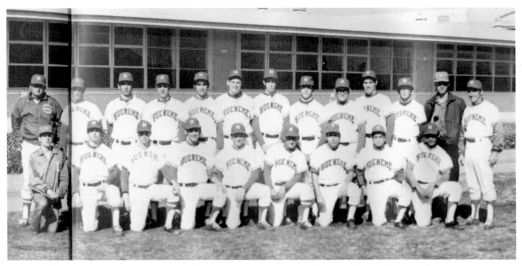

The 1973 Hueneme team continued their winning ways. Pictured here from left to right are the following: (first row) Jim Reik, Jim Reed, Mike Lake, Dennis King, M. Parte, Rene Martinez, Elvin Nichols, Tony Peraza, and Roland Martinez; (second row) coach Ron Cook, Bill Capko, Bill McIntyre, Curt Lewis, Ron Marple, Joe Davis, John Cummings, D. Alderson, Jim McDonald, Rob Woodside, Pete McIntyre, Larry Waddell, and coach Jerry White.

LOCAL TEAMS

The 1979 Oxnard College team won the Western State championship. Several players went on to have big-league careers. The champions included, from left to right, (first row) Robin Beecher, Terry Pendleton, Tim Seward, Yogi Skelton, Doug Rogers, Ralph Valenzuela, Ray Gallardo, and David Garcia; (second row) coach Jerry White, Ralph Gedies, Jerry Willard, Mike York, Kevin Coughlon, Curt Thrasher, Augie Avila, Jon Larson, Roger Frash, and coach Dennis King.

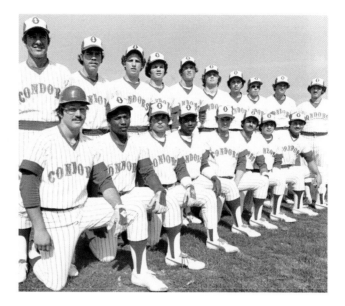

Jerry Willard, Terry Pendleton, and Jon Larson were part of the 1979 championship team. Larson, who batted .489 at Oxnard College and .346 at Azusa Pacific, returned to Oxnard and eventually took over the head coaching position. The 2006 team won the Western States championship. Oxnard College–produced big leaguers include Willard (1979), Pendleton (1980), Kevin Gross (1981), Mark Berry (1982), Howard Hilton (1983), Doug Simmons (1985), Steve Baker (1988), Tim Laker (1988), Josh Towers (1996), Jack Wilson (1998), and Paul McAnulty (2001).

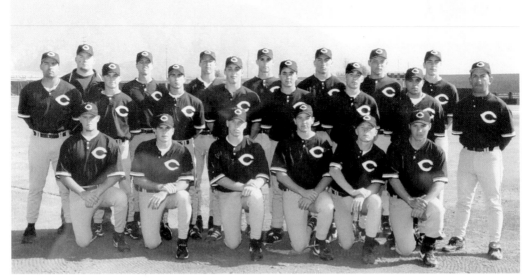

The 1999 Camarillo Scorpions featured several major-league draft picks, including Jeff Bannon (18th), Jay Caligiure (13th), Joe Borchard (1st). Pictured from left to right are the following: (first row) Joe Yingling, Robert Wagner, Brian Juell, Andy Alstot, Garrett Valencia, and Shane Miranda; (second row) coach Scott Cline, Chris Mykleby, Ryan Geisler, Justin Howe, Tony Murphy, Andy Kroneberger, Jeff Bannon, Jay Caliguiri, Joe Borchard, Justin Collins, Eric Foster, John Medina, Geoff Abbott, and coach Richard Jaquez.

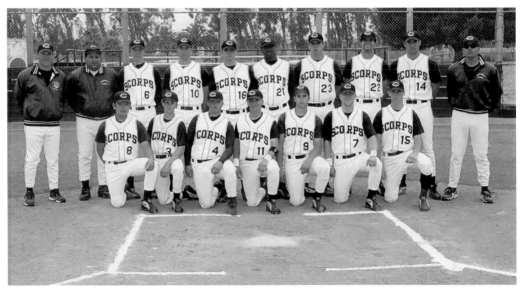

The 2002 Camarillo High School won the California Interscholastic Federation (CIF) Division I championship. Posing here from left to right are the following: (first row) Garrett Nishimori, Brett Scyphers, Justin Frash, Garrett Barlow, Matt Floryan, Brad Boyer, and Travis Sutton; (second row) coach Charlie Fiaco, coach Art Espinoza, Donald Brown, Todd Sandell, Corey Mapes, Delmon Young, J. T. Bricker, Dough McGee, Andrew Berkovich, and head coach Scott Cline.

LOCAL TEAMS

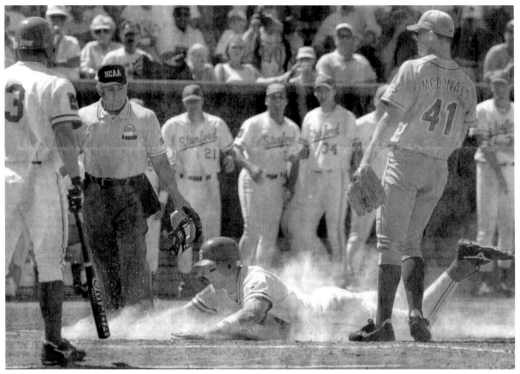

Camarillo High graduate and Stanford Cardinal junior Joe Borchard slides headfirst during the 2000 College World Series. Borchard led the Cardinal team with 19 home runs that year. He batted .346 for his three-year varsity career. In the postseason at Stanford, Borchard hit .390 with 30 hits in 85 at bats, including seven home runs.

Hitting aside, Joe Borchard covered a lot of ground in the outfield and had speed that was complemented by a strong arm. He also used that arm on the Cardinal football team as the backup quarterback to Todd Husak. Borchard entered nine games and completed 42 of 72 passes for seven touchdowns.

UCLA

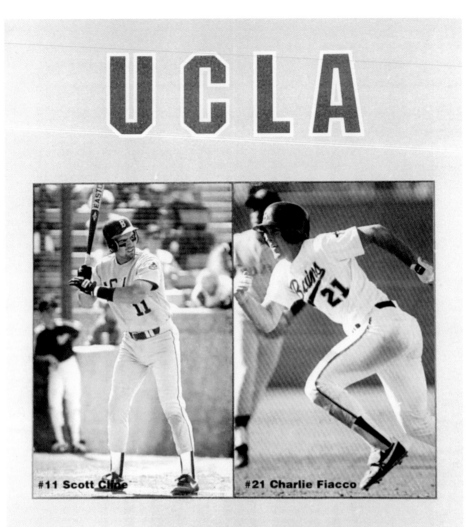

#11 Scott Cline #21 Charlie Fiacco

1989 BASEBALL
INFORMATION GUIDE

Scott Cline played for the first Camarillo team to make it to the CIF Southern Section Division I Championship Game in 1985. At the time, Cline set the record for most home runs by a Scorpion in a season (11), only to be tied by one of his players, Joe Borchard. It was again broken by another Scorpion he coached, Delmon Young, who clubbed 17. Cline went on the play third base at UCLA. Cline batted .312 for his college career and played with future pros Todd Zeile, Jeff Conine, Bill Haselman, and Eric Karros. Despite a serious knee injury that cost Scott his career, the Milwaukee Brewers picked him in the 26th round of the 1989 draft. Scott returned to his alma mater to lead the Scorpions to the county's first Southern Section championship in 2002.

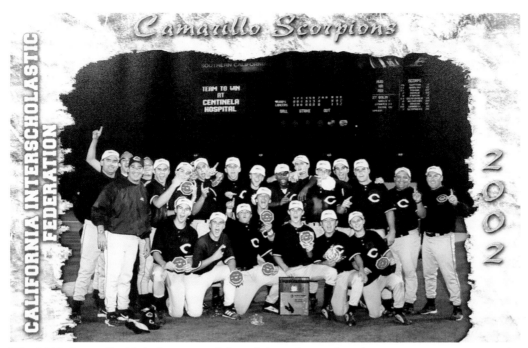

Camarillo Scorpions

2002

The 2002 Camarillo High Scorpions defeated the Lakewood High Lancers, 8-1, to capture the CIF Southern Section Division I championship at Edison Field in Anaheim. The Scorpions were led by pitcher Travis Sutton (14-0) and clutch hitters Brad Boyer, Andrew Berkovich, Donald Brown, and Delmon Young. The Scorpions became the only Ventura County team to complete the championship run. Previous attempts were made by Simi Valley (1993), Camarillo (1985), Hueneme (1979), Ventura (1970), and Oxnard (1956).

The team leaders are depicted here from the record-setting 2002 Camarillo High baseball team. Delmon Young broke the county season record with 17 home runs. Brad Boyer starred in three sports, hitting .467 and scoring a record-setting 61 runs in baseball, setting the school record for receiving yards in football with 1,358, and recording 66 steals as a guard on the basketball team. Justin Frash clubbed a county record 18 doubles.

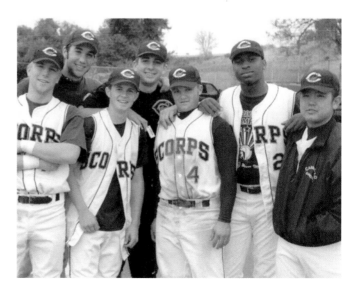

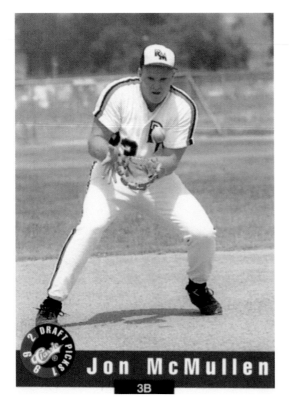

Jon McMullen 3B

Jon McMullen, the son of former major leaguer Ken McMullen, batted .439 during his two years on the Rio Mesa varsity team. He recorded 36 hits in 72 at bats his senior year for a .500 average. McMullen also clubbed 14 home runs in high school while, like his father, playing third base. The St. Louis Cardinals chose Jon in the eighth round of the 1992 draft.

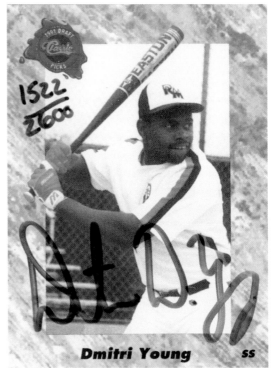

Dmitri Young SS

As a senior at Rio Mesa High School in 1991, Dmitri Young batted .425 with 11 home runs and 31 runs batted in and won *USA Today* High School All-American honors. He was drafted in the first round (fourth overall) by St. Louis and made his debut for the Cardinals on August 29, 1996, going one for four. He is the older brother of Delmon Young, who was the No. 1 overall pick in the 2003 draft.

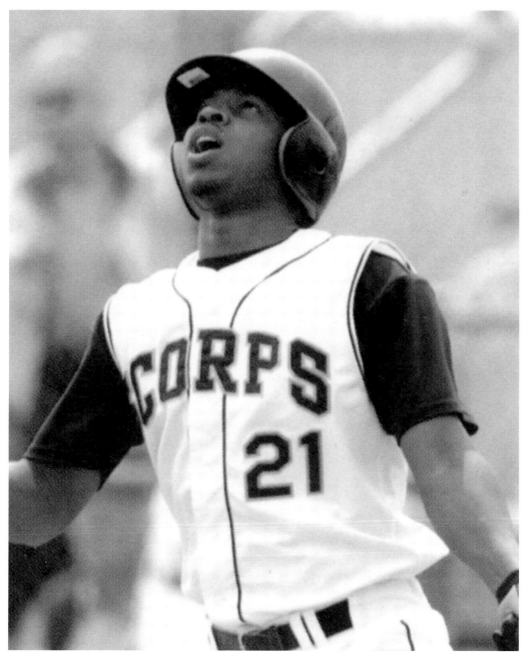

In addition to hitting .542 his junior year, the hard-throwing Delmon Young had a 1.66 ERA as a pitcher. With the bat, Young set the county record for hits (65) and home runs (17), surpassing Arnold Garcia's 1981 record of 16 for Channel Islands. Delmon also managed to hit .541 while starting all four years, never batting lower than .460 in any year. He was selected by the Tampa Bay Devil Rays in the first round (first overall) in the 2003 draft.

Derron Spiller, a pitcher from the Rio Mesa Spartans, was picked in the 44th round by the St. Louis Cardinals in the 1988 draft. Teammate Dan Penner was chosen the 18th round the previous year. Some other Spartans drafted were: Eric Flores, 1995, Dodgers; Graig Good, 1985, Tigers; Roger Hansen, 1980, Royals; Michael Mitchell, 1991, Royals; Goldie Wright, 1980, Angels; Chuck Yaeger, 1980, Twins; Jon McMullen, 1992, Phillies; Don Penner, 1987, Athletics; and Dmitri Young, 1991, Cardinals (first round). Another Spartans pitcher, Bobby Ayala, was signed as an undrafted free agent by the Reds in 1988.

David Soliz graduated from Rio Mesa High School in 1990 and was chosen All League, All County, and All CIF. He continued pitching for Cal State, Los Angeles, where he earned All-Conference selection. He began his coaching career at Cal State and tutored future major leaguers Jay Gibbons and minor-league pitcher Jeff Verplancke. Soliz returned to Rio Mesa as head varsity coach in 1999.

LOCAL TEAMS

Mike Lieberthal was the third player from Westlake High to make it to the major-league level (1st round, third overall, 1990, Phillies) following Matt Franco (7th round, 1987, Cubs) and John Snyder (13th round, 1992, Angels). While Franco put in eight years in the majors, plus three years in Japan, Lieberthal has put in 13 years and counting. Lieberthal has made the most of his baseball salary by purchasing $30,000 of tickets to give to families of children with cancer.

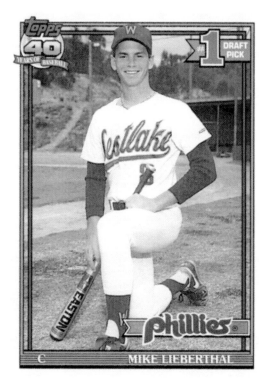

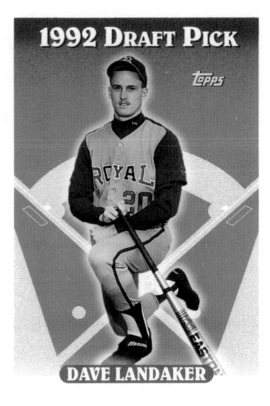

Dave Landaker led Royal High in Simi Valley to a 52-25 record in his three varsity seasons from 1990 to 1992, batting .450 overall. The Astros chose Landaker in the second round of the 1992 draft. He is 1 of 15 players to be drafted or signed from Royal High School between the years 1972 and 2006. The others include Greg Patterson, 1972, Orioles; David Garcia, 1972, Orioles; Jerry Jenkins, 1977, Brewers; Eric King, 1980, Giants (signed as an undrafted free agent); Joe Summers, 1987, Blue Jays; Travis Kinyoun, 1988, Tigers; Matthew Goebel, 1992, Padres; Philip Derryman, 1995, Expos; Benito Lemos, 1995, Phillies; Brett Egan, 1996, Phillies; Scott Rice, 1999, Orioles; Brett Wayne, 2002, Dodgers; and Kevin Harrington, 2006, Twins.

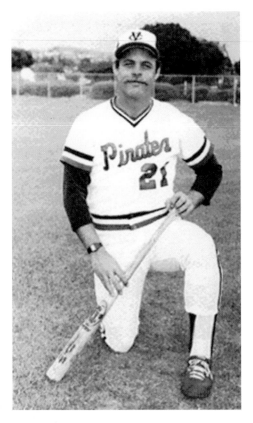

Gary Anglin graduated from Ventura High, where he played first base and pitched, earning All-CIF honors. He continued his success at Ventura College, where he was named All-Conference both years and the Outstanding Athlete of the Year in 1972. Anglin pitched successfully for two more years at UCLA before trying a year in the Canadian Baseball League. He also coached for 17 years at Ventura College. This all earned Anglin a spot in the Ventura County Hall of Fame in 2000.

The 2006 Ventura College Pirates baseball team won the Western State Conference title for the first time since 1989. The team was led by coach Don Adams, brothers Justin and Steven DeFratus, Mike Ziemke, Jerry Madueno, and the strong pitching of Jake Renshaw, who was drafted on the 10th round of the 2006 amateur draft by the Chicago Cubs. Renshaw follows in the footsteps of former Pirates Brook Jacoby, Brandon Knight, and Noah Lowry to make it to the majors.

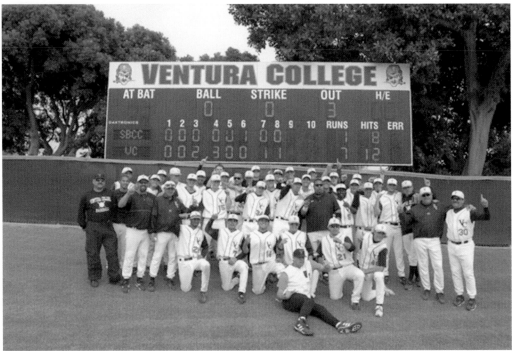

MINOR LEAGUES AND MAJOR AFFILIATES

Terry Tackett (center) is congratulated by teammates Jack Hiatt and Ernie Foley (left). Tackett played for the 1959 Oxnard High Channel League championship team as a First-Team, All-League pitcher and outfielder. The California Angels signed Tackett as a "bonus baby." Roland Hemond, who later signed Tackett's son Jeff while serving as general manager of the Baltimore Orioles, signed Tackett to the bonus deal. After five years in the minors, a stint shortened by arm troubles, Tackett moved on and taught and coached at Hueneme High. Tackett's efficient coaching skills earned the respect of his players and served as a blueprint for their future efforts, including those of this author.

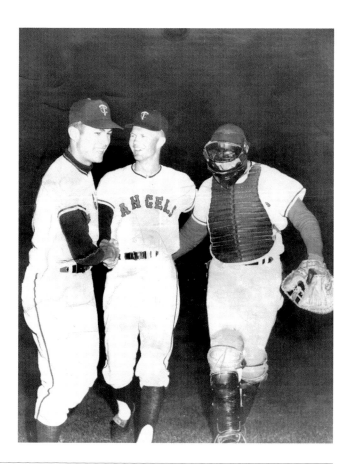

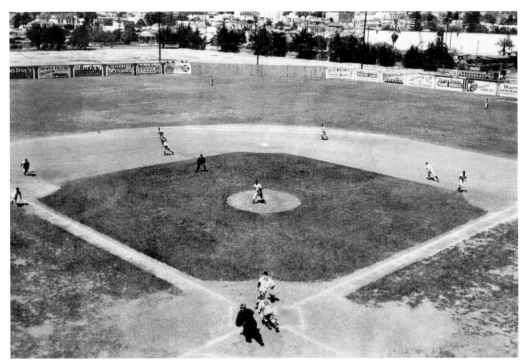

Box seats at Babe Ruth Field, home of the Ventura County Braves, used to cost $1.10, the same price as seats in the reserved grandstand. Remaining grandstand seats were 80¢; bleacher general admission seats were 55¢; children under 12 were admitted free; and students could get a reduced price of 40¢.

The Ventura County Braves played at Babe Ruth Field at Seaside Park in Ventura from 1950 to 1952, following three years as an affiliate of the New York Yankees. Attendance for the 1950 season was 67,916 for 63 games, averaging 1,078 paying customers. The stockholders report for 1950 blamed poor weather, the new medium of television, and the location of the park as reasons for the disappointing numbers.

MAJOR-LEAGUE AFFILIATES

This Braves' program was published by Ventura Printing at 38 South Oak Street in Ventura and cost 10¢. The cover features an image of Lucky Vital, a 5-foot, 10-inch, 23-year-old outfielder from Yuba City. Some of the sponsors were The Sportsman Restaurant; Hap's Cleaners; Korb's Trading Post; Ferguson's Furniture and Philco; and Chevron Gas Station "dealers" Gene Lewis, Kirby Willis, Burke Crane, Norman Hiatt, Pat McNulty, Ed Hagle, and Archie Connelly.

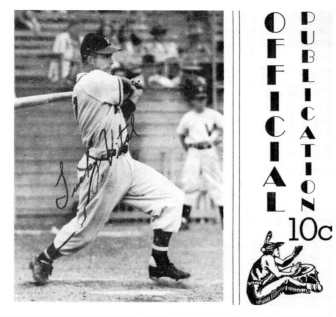

OFFICIAL PUBLICATION 10c

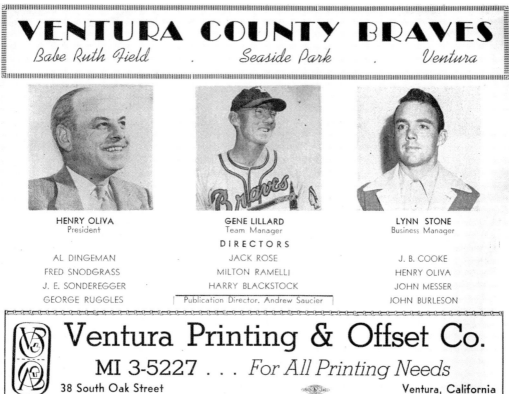

VENTURA COUNTY BRAVES

Babe Ruth Field . Seaside Park . Ventura

HENRY OLIVA
President

GENE LILLARD
Team Manager

LYNN STONE
Business Manager

DIRECTORS

AL DINGEMAN	JACK ROSE	J. B. COOKE
FRED SNODGRASS	MILTON RAMELLI	HENRY OLIVA
J. E. SONDEREGGER	HARRY BLACKSTOCK	JOHN MESSER
GEORGE RUGGLES	Publication Director. Andrew Saucier	JOHN BURLESON

Longtime baseball aficionado Henry Oliva served as president of the Ventura County Braves. His board included Fred Snodgrass, J. E. Sonderegger, George Ruggles, Jack Rose, Milton Ramelli, and Harry Blackstock.

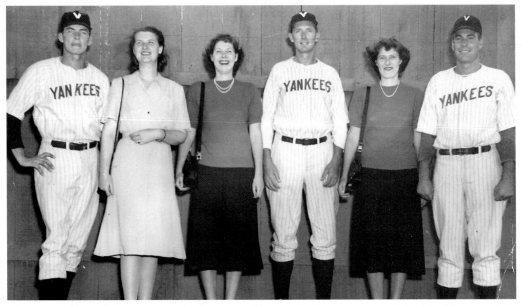

Three members of the Ventura Yankees match up with three women of the Tip-Toppers club. The Los Angeles-based organization met up with the local Yanks for an evening of dancing at the Elks Temple in Los Angeles. Requirements for women members included a minimum of 6 feet in height. The men had to be at least 6-feet, 4-inches tall. Pictured here from left to right are pitcher Bill Boemler, Ellen Rice, Joan Havins, first baseman Bob White, Jean Havins, and pitcher Doug Essick.

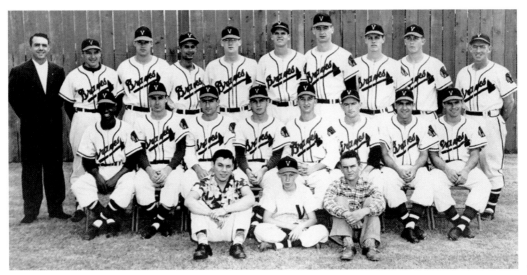

The Ventura County Braves of 1950 played in the California League against the Fresno Cardinals, Visalia Cubs, Modesto Reds, Santa Barbara Dodgers, Bakersfield Indians, and San Jose Red Sox. Many future big leaguers got their start in the California League, including Harry Hooper, Don Drysdale, Joe Morgan, Don Sutton, Rollie Fingers, Sparky Anderson, George Brett, Dennis Eckersley, and Kirby Puckett.

MAJOR-LEAGUE AFFILIATES

The Ventura County Baseball Club stock sold for $10 a share and held a capital stock of $100,000. These 15 shares, signed by president Henry Oliva and secretary J. E. Sonderegger, belonged to J. F. Tefferteller.

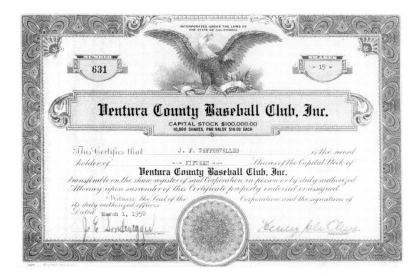

The Ventura County Gulls played a season at Ventura College of all day games because of a home field with no lights. An affiliate of the Toronto Blue Jays, the team was purchased by former big leaguers Ken McMullen and Jim Colborn and investor Jim Biby. Pictured here from left to right are the following: (first row) trainer Al Olson, Zac Paris, Mark Dickman, batboys Todd Tushla and Tim Biby, Pablo Reyes, David Walsh, and equipment manager Peter Nielson; (second row) manager Glenn Ezel, Rob Ducey, Oman Malave, Luis Reyna, Santiago Garcia, Jeff Musselman, Eric Yelding, Sandy Guerrero, and Oscar Escobar; (third row) owner and general manager Jim Biby, coach Alfredo Ortiz, William Shanks, Hugh Brinson, Francisco Cabrera, Geronimo Berroa, James Bishop, Tom Wasilewsi, Todd Provence, Darryl Landrum, Jose Mesa, Greg Myers, Mike Jones, Domingo Martinez, Todd Stottlemyre, and owner Ken McMullen. Several Gulls made their way to the big leagues, including Stottlemyre, Cabrera, Mesa, Berroa, Ducey, Myers, Reyna, and Musselman. David Wells also threw some innings for the local club. The 1986 team went 75-67, finishing in fourth place.

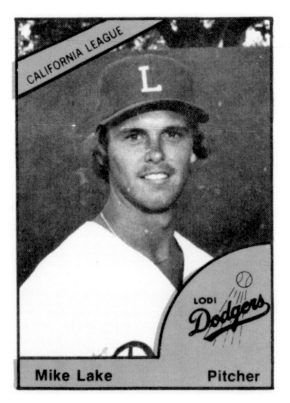

Mike Lake Pitcher

Left-handed pitcher Mike Lake graduated from Hueneme High in 1975 and was drafted by the Dodgers after batting over .500 his senior year. Lake pitched for the Lodi Dodgers until arm troubles ended his promising start. Some of Lake's teammates from the Lodi team who made it to the big club included Rudy Law, Ron Roenicke, Max Venable, and Mark Bradley.

Josh Lake, like his father Mike, used his strong arm and consistent bat to attract interest from several baseball scouts. The Milwaukee Brewers drafted the younger Lake in 1999 after he played amateur ball at Buena High School in Ventura and Oxnard College. Unfortunately, like his father, arm trouble brought Lake's baseball career to an end.

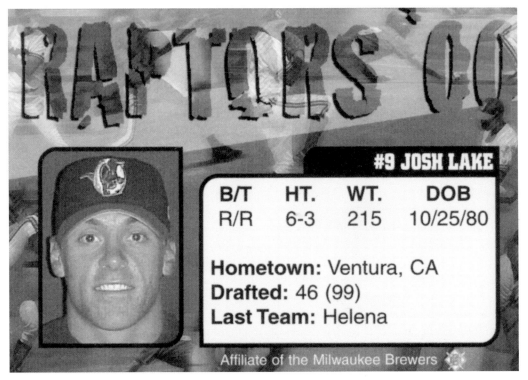

#9 JOSH LAKE

B/T	HT.	WT.	DOB
R/R	6-3	215	10/25/80

Hometown: Ventura, CA
Drafted: 46 (99)
Last Team: Helena

Affiliate of the Milwaukee Brewers

A cousin to Mike Lake, Steve Lake graduated from Lennox High School and was drafted in the third round in 1975 by the Baltimore Orioles. He made his major-league debut on April 9, 1983, with the Chicago Cubs and collected his first major-league hit in his second at-bat. Primarily a backup catcher, Lake batted a solid .268 in 476 games. He appeared in one postseason game with the 1984 Cubs and in three with the 1987 Cardinals; in four postseason at bats, Lake stroked a single and a double.

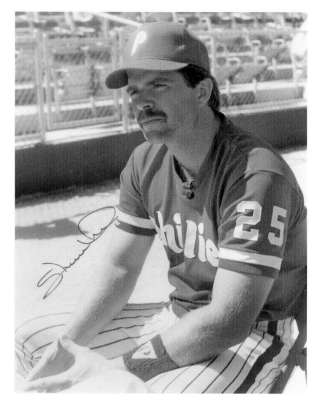

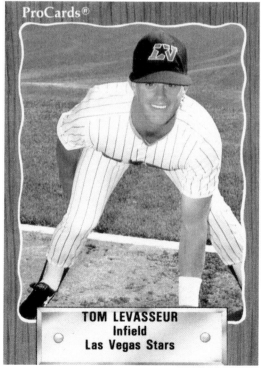

Tom LeVasseur was born in Ventura and played with Paula High School and the VC Pirates. He was drafted out of San Diego State University in the eighth round of the 1986 draft. LeVasseur played in the minors for teams in Spokane, Reno, Riverside, Wichita, and Las Vegas. By 1995, LeVasseur was managing in the minors for the Mariners' rookie ball club in Arizona. In 1999, he took the Padres' Rancho Cucamonga club to a second-place finish.

Ernie Carrasco found success in the bullpen in 1984 as the Savannah Cardinals' top reliever. By 1986, Carrasco was pitching for the Cardinals' Arkansas Travelers team. The headline from a July 23, 1984, article in the *Savannah Morning News* demonstrated the manager's faith in his closer, "SavCards' Lloyd Merritt spells relief C-A-R-R-A-S-C-O." Carrasco went 11 for 12 in save situations without allowing a run in more than a month.

Although Howard Hilton did not pitch while attending Hueneme High; he pursued his pitching career at the University of Arkansas. Drafted by the Cardinals in the 22nd round in 1985, Hilton made a brief appearance for St. Louis in 1990, pitching in a couple of games without giving up a run in either appearance.

In 1986, Ernie Carrasco was promoted to the Cardinals' Double-A team, the Arkansas Travelers of the Texas league. Over 200 alumni from the Travelers teams made it to the majors as far back as Tris Speaker, Bill Dickey, Richie Allen, Ferguson Jenkins, and Keith Hernandez, as well as Ventura County big leaguers Jack Wilson and Dmitri Young. After seven years in the minors, Carrasco became a teacher and baseball coach at his alma mater, Channel Islands High School.

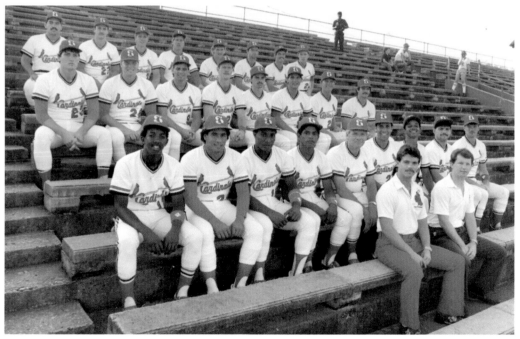

The 1984 Savannah Cardinals finished in second place in the league, and included, in the front row, trainer Wayne Harmon (left) and general manager Karl Rogozenski. Ernie Carrasco is on the far left in the back row.

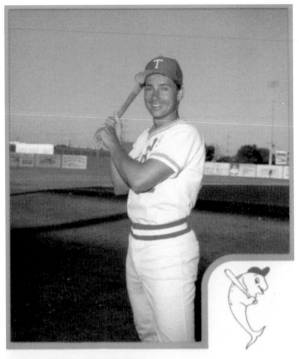

Mark Berry graduated from Hueneme High in 1981 and went on to play at Oxnard College and at the University of Arkansas. Berry was drafted in the sixth round of the 1984 draft by the Cincinnati Reds. Through the 2006 season, Berry has been a part of the Reds organization for 23 years—7 as a player in the minors and the last 8 years as a coach with the big club. Berry was the Most Valuable Player on his Tampa club in 1986 and was named the Southern League's Manager of the Year in 1996 while helming the Reds' Chattanooga squad.

MARK BERRY
Tampa C

Don Rowe pitched only 55 innings in the major leagues for the 1963 Mets. As a pitching coach in the Milwaukee Brewers organization, the gruff, straightforward Rowe once punctuated a session with pitchers by asking a confident young Johnson "Woody" Wood where he was from. Woody replied, "Oxnard, California." Sizing up the prospect, Rowe mentioned he had played in Oxnard, giving Woody the false impression that the coach would go easy on him. With this, Rowe sent Woody on a series of sprints that an Olympic athlete could not endure. Woody's lesson, remembered years later, was that "fatigue makes cowards of all of us."

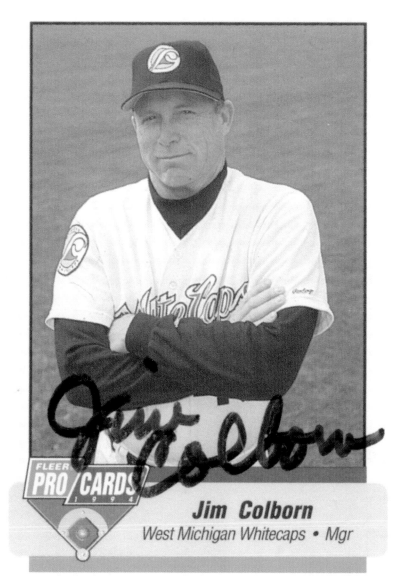

Jim Colborn
West Michigan Whitecaps • Mgr

After a 10-year career as a major-league pitcher, Jim Colborn has worked as a scout, manager, and pitching coach. From 1984 to 1986, Colborn was a pitching coach for the Chicago Cubs Triple-A club in Iowa. Three seasons later, he became a manager in the Oakland A's system. In 1994, Colborn was named the first manager of the West Michigan Whitecaps. Colborn's Modesto team posted a league-best 82-58 record in 1996. Colborn became pitching coach for Orix of the Japanese Pacific League from 1990 to 1993. While he served as director of Pacific Rim Scouting for the Seattle Mariners, Colborn was instrumental in signing the 2000 and 2001 American League Rookies of the Year, Kazuhiro Sasaki and Ichiro Suzuki. Colborn became the Dodgers pitching coach in 2001, and he followed manager Jim Tracy to the Pittsburgh Pirates for the 2006 season. The 2003 Dodgers pitching staff led the majors with a 3.16 ERA with 17 shutouts while striking out a franchise-record 1,289 batters.

JOHNSON WOOD P

Johnson "Woody" Wood was born on a Native American reservation in Washington State and grew up on the Port Hueneme Seabees base. He played at Hueneme High, Oxnard College, and Pepperdine University before being drafted in 1980 in the 14th round by the Milwaukee Brewers. Woody played in the Pioneer, Midwest, in Texas Leagues, as well as in the Suncoast League in Canada. He used a variety of pitches to prolong his career in Belgium before coaching at Santa Clara High School and with the Pacific Suns.

Jere Longenecker played for the Hueneme High Vikings and the Pepperdine University Waves, from which he was drafted in the 26th round of the 1983 draft as a first baseman. He played the 1983 season at Butte, Montana, and batted .308. For the 1984 season, Longenecker was promoted to the Charleston, South Carolina, Royals club, collecting 133 hits and 29 stolen bases. His 1985 season was split between Memphis and Fort Myers.

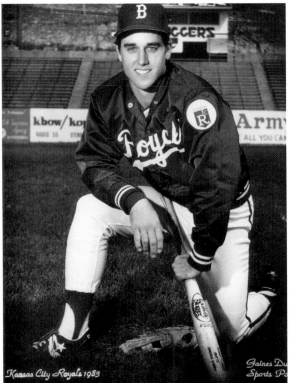

MAJOR-LEAGUE AFFILIATES

Outfielder Steve Santora played at Hueneme and Ventura College before being drafted in the fifth round in 1985 by the San Francisco Giants. Santora played for the Everett Giants in Washington State and was in the top three in most of the major hitting categories. After one season, Santora returned to the family's construction business.

Jack Shuffield played for Ventura High before donning the cleats for Ventura College in 1982, leading the team in hits (48), runs (32), RBIs, and doubles. The Kansas City Royals selected Jack in the fourth round of the 1982 draft, and he went on to play for their Sarasota, Florida, team. After collecting 63 hits in 243 at-bats, Jack was promoted to the Charleston, South Carolina, team in the South Atlantic League in 1983.

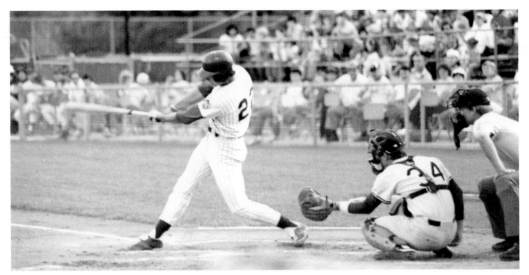

Roger Frash was chosen in the first round (second overall) in the 1980 draft by the New York Mets. Frash spent three years in the New York Mets organization, playing in the New York–Penn League, which he led in batting with a .346 average, before spending two seasons at Lynchburg, Virginia. He was a teammate of future big leaguers Daryl Strawberry, Kevin Mitchell, Billy Bean, and Jose Oquendo.

To Roger Frash, baseball has been a family affair. He is the brother-in-law of Steve Santora, who played in the San Francisco Giants organization. Frash is also the uncle of Josh Towers (see page 77). Roger's son, Justin, is on the 2007 Brooks Wallace Watch List after his stellar junior year for the University of Hawaii in 2006. Roger Frash has kept his glove in the game by raising money for, and coaching at, Oxnard College.

MAJOR-LEAGUE AFFILIATES

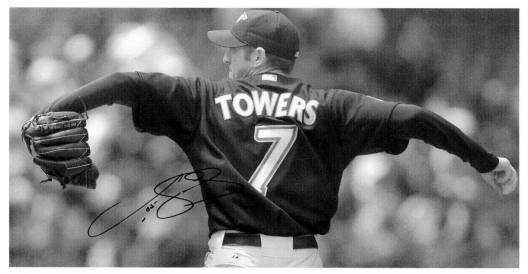

Josh Towers is another Hueneme High/Oxnard College connection to the pros. Drafted in the 15th round of the 1996 draft by the Orioles, Towers used his pinpoint control to work his way up through the minors from Bluefield, Delmarva, Frederick, Bowie, and Rochester to debut with the Baltimore Orioles on May 2, 2001. His line for the day was a scoreless one and one-third innings.

After breaking the county record for most doubles in a season at Camarillo and helping the Scorpions earn the county's only Southern Section championship in 2002, Justin Frash played on the 2005 Western State Championship team at Oxnard College, earning All-League and All-Southern Section honors. Frash made the 2007 Brooks Wallace Collegiate Player of the Year watch list after hitting .359 with 56 RBIs and 13 doubles in his 2006 junior year.

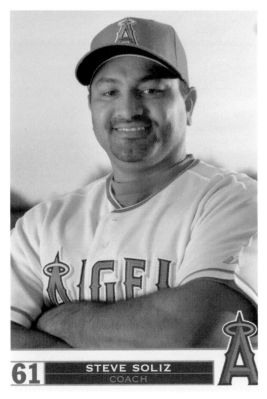

61 STEVE SOLIZ
COACH

Steve Soliz sets up behind the plate in an exhibition game against the Padres and their great hitter, Tony Gywnn. Soliz, like his brothers and father, played his high school ball at Rio Mesa High. After a successful senior year at California State University, Los Angeles, the Cleveland Indians drafted Soliz in the 13th round in 1993.

Steve Soliz played eight seasons in the Cleveland Indians organization and two in the San Diego Padres system, ending his career in 2001. In 1998, Soliz played for the Indians' 1998 Triple-A World Series team in Buffalo. Regulars in the 1990s for Buffalo included Richie Sexon and Brian Giles. An elbow injury cut short Soliz's career in 2001. After he served as a volunteer coach for the Yuma Bullfrogs, Steve joined the Anaheim Angels as bullpen coach.

MAJOR-LEAGUE AFFILIATES

The three Soliz brothers from the Rio Mesa Spartans carried on the family baseball tradition for the Cal State Golden Eagles. Pictured here from left to right are Steve, Richard, and Dave. Dave, the second oldest, was a promising pitcher until his arm required "Tommy John" surgery, which he decided against. Pitcher Richard Soliz recorded an 8-1 season for the 21-7 Spartans before following in his brothers' footsteps to Cal State.

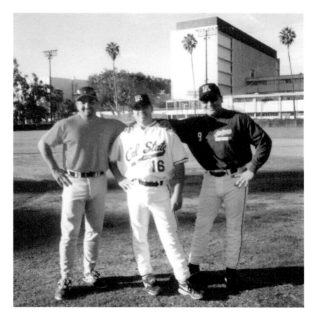

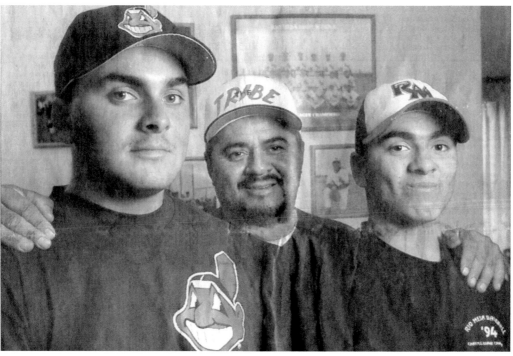

The *Ventura Star Free Press* ran a feature article on the Soliz brothers on June 15, 1994. The boys' father and uncle were also accomplished players. While their father was a successful catcher at Rio Mesa and Ventura College, their uncle Archie Soliz was a two-sport star at Santa Clara High School in Oxnard. Playing quarterback for legendary Lou Cvijanovich, Soliz was also an All-CIF pitcher in 1964 and 1965. He pitched an 18-inning contest against the touring Riele team from Sonora, Mexico.

Matt Merricks is one of three family members to be drafted within in a three-year period. Matt was drafted in the sixth round by the Atlanta Braves in 2000; older brother Charles was selected out of UCLA by the Colorado Rockies in the 17th round and played three minor-league seasons; and cousin Alex Merricks was drafted in the fourth round by the Minnesota Twins in 2002. Matt pitched four years for various minor-league teams in the Braves organization before being traded to the Dodgers organization in 2004 and pitching in Vero Beach. The Texas Rangers signed Matt to a minor-league contract for the 2007 season.

Alex Merricks's 90-plus-mile-per-hour fastball made him a feared high school pitcher. He struck out more than a batter per inning, leading to his high draft selection (fourth round) by the Twins. After a strong start in rookie ball with a 2-0 record and a 1.80 ERA, the organization altered Alex's delivery, sacrificing "the heater" to extend his career and effectiveness.

MAJOR-LEAGUE AFFILIATES

The left-handed, 6-foot, 6-inch Scott Rice played basketball and baseball while attending Royal High in Simi Valley. Rice is one of 13 players to be drafted out of Royal High since 1972, when David Garcia and Greg Patterson were drafted by the Baltimore Orioles. The Orioles drafted Rice in the first round in 1999. During the 2005 campaign, he went 9 straight outings in relief without allowing a run and 9 of 10 to close the season. In 2006, Rice pitched for Triple-A Ottawa.

Tyler Adamczyk is 1 of 20 players from Westlake High to be drafted between the years 1982, when the San Francisco Giants picked John Hughes, and 2006, when the Cleveland Indians selected Travis Turek. Adamczyk, who was picked in the seventh round by the Cardinals in 2001, led the 2000 Warriors to the Marmonte League title, along with Jesse Kozlowski, who was also chosen by the Cardinals in the 43rd round. Teammate Jeff Dragicevich was drafted in the 18th round by the Rockies in 2004. Jeff's older brother Scott was drafted by the Blue Jays in the 36th round. Mike Nickeas, a fifth-round pick of the Rangers, and Ryan McCarthy, a ninth-round selection by the White Sox, were part of the second Westlake High championship team in 2001.

Simi Valley graduate Ryan Hankins was drafted in the 13th round of the 1997 draft by the White Sox. The versatile Hankins has played most infield positions as well as catcher. With his compact power, he has clubbed 15 home runs twice while working his way up to the Triple-A level. Hankins also contributed to the 2004 Olympic team.

Jay Caligiuri played at Camarillo High and California State University, Los Angeles. He was drafted in the 13th round by the New York Mets in the 2001 amateur draft. Caligiuri played pro ball for teams in Brooklyn, Capital City, Columbia, St. Lucie, Norfolk, and, in the 2006 season, in Binghamton. The first baseman/third baseman hit 18 home runs for that Double-A team.

MAJOR-LEAGUE AFFILIATES

Kevin Howard played for Westlake High and the University of Miami, where he batted .413 as a freshmen and .353 as a junior before being selected in the fifth round in 2002 by the Cincinnati Reds. The second basemen played for Daytona in 2003, Potomac in 2004, Chattanooga in 2005, and Trenton's Double-A club in 2006.

Jeff Bannon played for Camarillo High in 1997, where he batted .430 and was named to the All-Marmonte League first team, graduating with a 4.0 grade-point average. Bannon played for the University of Santa Barbara Gauchos and worked his way up the chain of minor-league teams, including Stockton, Potomac, Chattanooga, and the Reds' Triple-A club in Louisville. The 6-foot, 4-inch Bannon began his career as a shortstop. By 2006, the Reds began grooming the versatile Bannon into a utility player, maximizing his opportunity to reach the majors.

Brett Wayne graduated from Royal High School in Simi Valley in 1998, where he posted a 7-0 record with a 1.83 ERA while also batting .356 with 53 RBIs. Pitching and playing shortstop for St. Mary's College, Wayne batted .328 his junior year and .301 his senior year when he wasn't taking the mound for the Gaels. The Los Angeles Dodgers drafted Wayne as a shortstop in the 22nd round of the 2002 draft. By the 2004 season, Wayne converted back to the mound and pitched for the Visalia Oaks for the "high" Single-A team for the 2005 and 2006 seasons.

Greg Ramirez pitched for the Rio Mesa Spartans and the Pepperdine Waves before being drafted in the 22nd round of the 2003 draft by the New York Mets. At Pepperdine, the 6-foot, 4-inch right-hander posted a 9-3 record with a 2.89 ERA and was named the 2003 West Coast Conference Pitcher of the Year. Soon after signing, Ramirez joined the Mets' Brooklyn club, for whom he posted a 2.96 ERA that season. In 2004, he moved up to the Capital City team, improving to a 7-0 record backed by a 2.06 ERA in 38 games. After a promotion and 18 games for "high" Single-A St. Lucie for the 2005 season, Ramirez suffered arm troubles, keeping him out of the 2006 season.

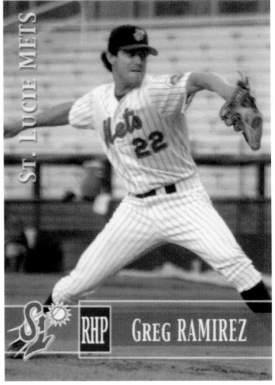

ST. LUCIE METS

RHP GREG RAMIREZ

Jered Weaver is the younger brother of major-league pitcher Jeff Weaver and the cousin to NFL tight end Jed Weaver. After a successful pitching career at Simi Valley High, Weaver went on to an even more impressive college career at Long Beach State, where he won the 2004 Roger Clemens Award as the college pitcher of the year as well as the Golden Spikes Award as the best amateur player. He posted a career 37-9 record, including a 15-1 mark and 1.62 ERA his senior year. Weaver was drafted in the first round (12th overall) in 2004 by the Angels (see page 117).

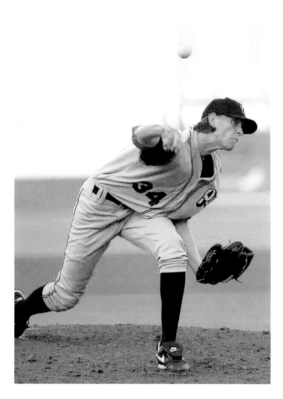

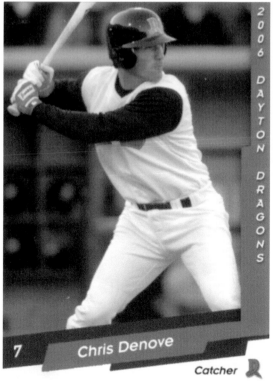

2006 DAYTON DRAGONS

7 Chris Denove

Catcher

Chris DeNove was born in Westlake and played at Agoura High School. The 6-foot, 1-inch catcher played his college ball at UCLA, where he batted .319 his first year. His average slipped in his third year, yet the Cincinnati Reds drafted him in the 32nd round. At Billings, Montana, he hit a solid .261 and he was promoted to the Dayton, Ohio, team for the 2006 season.

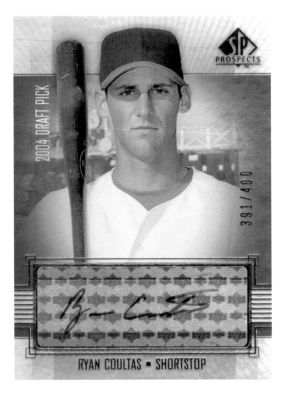

2004 DRAFT PICK

SP PROSPECTS

391/400

RYAN COULTAS • SHORTSTOP

Infielder Ryan Coultas played for the Ventura Cougars and the University of California, Davis Aggies. He paced the Aggies to a 32-7 record. Coultas was drafted by the New York Mets in the sixth round of the 2004 draft. He played 44 games and batted .254 for the Mets' Brooklyn team. Promoted to Hagerstown, Maryland, Coultas improved his batting average to .289 while anchoring the middle of the infield as shortstop. His 2006 season was split between Hagerstown and St. Lucie.

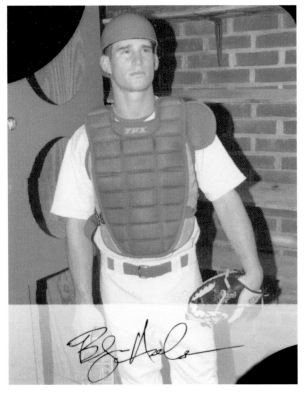

Bryan Anderson graduated from Simi Valley High in 2005. Anderson's quick release behind the plate and good bat speed led the Cardinals to pick him in the fourth round that year. He picked off 15 out of 16 potential base stealers his senior year. Bryan's junior-year teammate, the 6-foot, 4-inch infielder Nick Giarraputo, was chosen in the 12th round of the 2006 draft by the Mets. Other Simi Valley Cardinals who were drafted include David Milstein, 1986, Boston; Kevin Nykoluk, 1993, Montreal; Trevor Leppard, 1993, Pittsburgh; Coby Judd, 2001, Detriot; and Mario Colletto, 2004, Cincinnati.

MAJOR-LEAGUE AFFILIATES

THE MAJORS

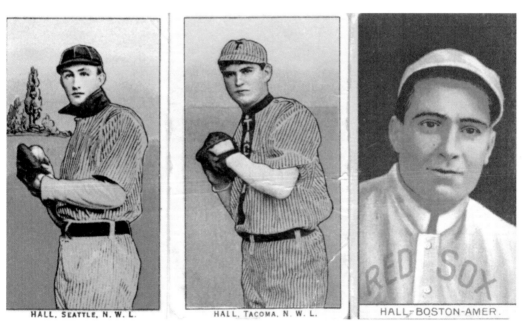

HALL, SEATTLE, N. W. L. HALL, TACOMA, N. W. L. HALL-BOSTON-AMER.

Charley Hall was born in Ventura in 1884 and began pitching professionally at age 20 in 1904 for the Seattle Indians of the Pacific Coast League, winning 28 games. By 1906, Hall was pitching for the Cincinnati Reds, thus becoming the first player from the county to reach the major leagues. By 1909, Charley Hall was playing for the Boston Red Sox. The three tobacco cards on this page represent Hall, beginning with the Seattle card on the left and ending with his Boston Red Sox card on the right.

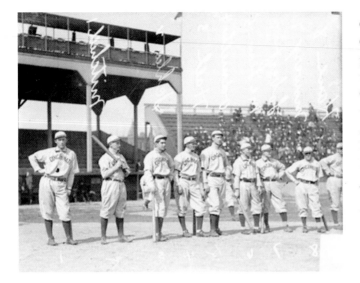

Charley Hall and his Cincinnati Reds teammates pose near home plate at the West Side Grounds in Chicago. Pictured from left to right are Mike Mitchell, Admiral Schlei, Charley Hall, Fred Odwell, Larry McLean, Hans Lobert, Mike Mowery, John Kane, and unidentified. Hans Lobert would tour the West Coast with the Giants in 1913 and raced against a cow pony at the aforementioned exhibition game in Oxnard.

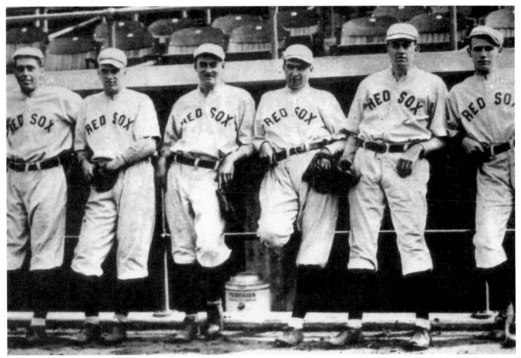

Charley Hall's nickname was "Sea Lion," apparently because he had a deep voice. Hall won 15 games for the Red Sox during their 1912 championship year. Charley became one of baseball's first relief specialists. Of his 188 appearances, 107 were in relief, usually when outs were needed. One of Hall's most prized moments came while pitching for the Sox and facing baseball's first "murderer's row": Ty Cobb, Sam Crawford, and Jim Delahanty of the Detroit Tigers. With the Sox up by one run in the ninth inning, Hall fanned all three future Hall of Famers to preserve the victory. The pitching staff for the Boston Red Sox in 1912 included, from left to right, Larry Page, Hugh Bedient, Buck O'Brien, Charley Hall, Ray Collins, and Smokey Joe Wood.

THE MAJORS

The durable Charley Hall pitched professionally for 21 years. Even beyond his last year in the majors, 1918 with Detroit, Hall continued to dominate batters no matter what league he pitched in. He won a total of 338 games in the majors and minors. In 1915, Hall won 16 games in a row in the American Association and went 27-8 in 1920. Hall also pitched four no-hitters during his career.

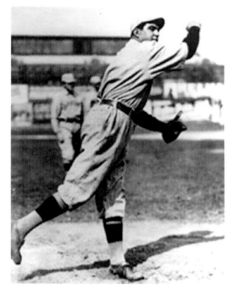

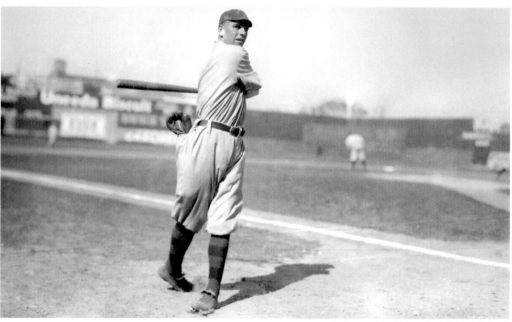

The second major leaguer from Ventura County was Jack Barnett, who played in 59 games for the St. Louis Cardinals in 1907, batting .238 for his one season. Although he appears in *Total Baseball* as "Burnett," his family name is Barnett, one of the pioneering families of Ventura County. Fred Snodgrass, pictured, followed Barnett and put in nine years in the big leagues. Snodgrass switched from catcher to outfielder in 1909, resulting in a .321 average the next year and 51 stolen bases in 1911. His career average was .275. He then started one of the county's first appliance businesses, was on the Oxnard City Council by 1930, and in 1937 was appointed mayor. He moved to Ventura to continue farming—growing lemons and walnuts—and to serve on the board of directors of the Bank of A. Levy.

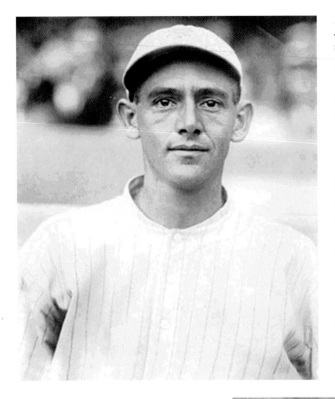

Joe Wilhoit was from Santa Paula and holds the distinction of hitting in the most consecutive games in the history of professional baseball at 69. While Joe DiMaggio hit in 56 consecutive games for the New York Yankees in 1941 (after posting another long streak in the minors of 61 games for the San Francisco Seals in 1933) and was an icon of his era, Wilhoit spent parts of four undistinguished years playing for the Red Sox, Pirates, and Giants before being released in 1919. He was later acquired by the Wichita Jobbers of the independent Western League and proceeded to make history. During the streak, Wilhoit had 153 hits in 299 at bats for a .512 average. He retired to Santa Barbara and died in 1930.

Stanley George "Frenchy" Bordagaray lettered in baseball at Fresno State University and made his professional debut in 1931 with the Sacramento Solons of the Pacific Coast League. By 1934, he was signed by the Chicago White Sox and began an 11-year career in the big leagues. He played for the Sox, Dodgers, Cardinals, Reds, and Yankees before spending his last four years back in Brooklyn for the Dodgers. He retired in 1945. The swift-footed infielder had a solid .283 average for his career and played in two World Series. By 1961, Frenchy returned to California and lived in Ventura, where he became involved with youth programs.

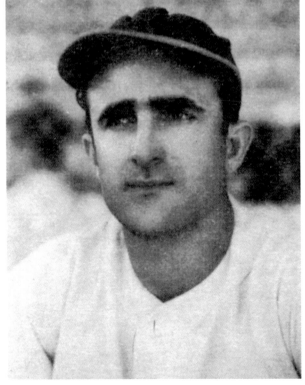

THE MAJORS

Frenchy Bordagaray, known for his eccentric personality, attempted to become a movie actor. During the filming of a 1936 John Ford film, *The Prisoner of Shark Island*, Frenchy grew a mustache for the part. He liked the look so much that he kept it, adding a goatee and monocle. After a prolonged batting slump by the Coalinga native, Dodgers Manager Casey Stengel issued an ultimatum on facial hair. In 1972, Bordagaray was invited by Oakland A's owner Charley Finley to serve as chairman for a "Mustache Day."

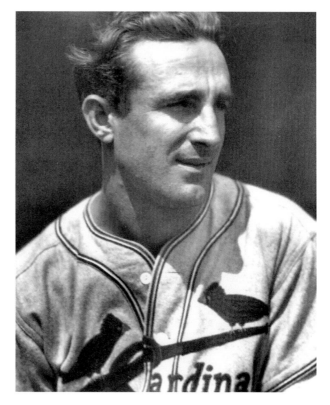

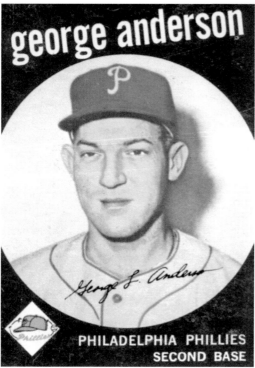

George "Sparky" Anderson was drafted by the Dodgers and played six seasons in the farm system. His only major-league season was in 1959, when he played shortstop for the Philadelphia Phillies and batted .218 in 152 games. The Cincinnati Reds hired Sparky in 1970, and his "Big Red Machine" won two World Series. After nine seasons with the Reds, Anderson spent 18 seasons with the Detroit Tigers. He managed more than 4,000 games and totaled the fourth-highest number of wins by a manager in baseball history: 2,194. The 30-year Thousand Oaks resident hosts an annual golf tournament for the University of California Lutheran. The college has repaid the favor by naming its baseball complex after the Hall of Fame manager.

Hard-throwing, left-handed pitcher Denver "Denny" Clayton Lemaster was a member for the dominant Oxnard High baseball team that included another future big leaguer, Ken McMullen, as well as several other players who went on to have successful baseball careers as coaches, softball players, minor leaguers, and as father figures. The Milwaukee Braves signed Lemaster as a free agent in 1958 for a $60,000 bonus.

In a 1959 game in the Texas League, minor-league rookie Denny Lemaster struck out 11 consecutive batters. He made his major-league debut on July 15, 1962, for the Milwaukee Braves and ended the year with a 3.01 ERA in just under 87 innings. In 1963, Lemaster averaged 7.22 strikeouts per nine innings pitched, ranking fifth in the league, and tallied 190 strikeouts for the season. He averaged close to that for three years, and in 1967, he made the National League All-Star team. Despite intermittent control problems, Lemaster maintained a 3.58 ERA for his 11-year career, also pitching for the Houston Astros and Montreal Expos.

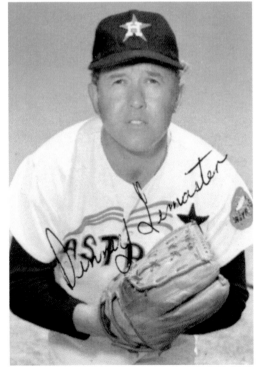

THE MAJORS

Jim Colborn pitched for the Santa Paula High Cardinals as well as the University of Washington and Whittier College. After graduating from Whittier with a degree in sociology, Colborn entered the University of Edinburgh in Scotland to earn a master's degree. While pitching against the Netherlands in the 1966 European All-Star Game, Colborn struck out 21 batters. Soon after, in 1967, the Chicago Cubs signed Colborn.

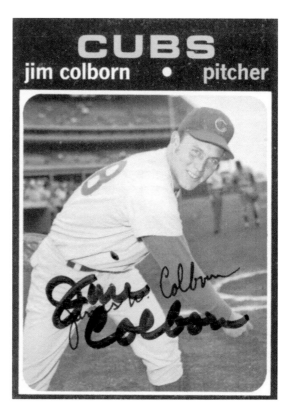

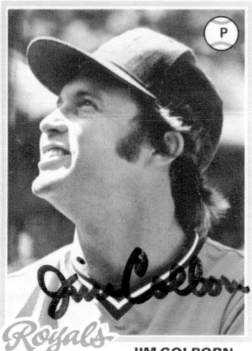

JIM COLBORN

Jim Colborn began his minor-league career with the Lodi Crushers, for whom he averaged over a strikeout an inning. By 1969, Colborn was pitching for the Cubs. Before the 1972 season, he was traded to the Milwaukee Brewers for Jose Cardenal, and by 1973, he was named to the American League All-Star Team and on his way to becoming the Brewers' first 20-game winner. He also won 18 games for the Royals in 1977, pitching a no-hitter on May 4. He ended his career with the Seattle Mariners in 1978. He won 83 games and posted a 3.80 ERA for his career.

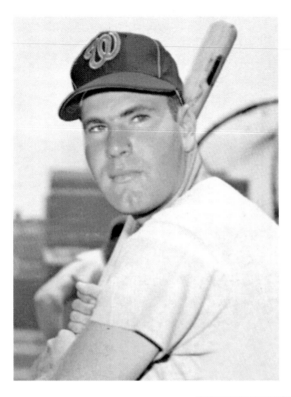

After a dominating high school career at Oxnard, Ken McMullen signed a contract to play for the Dodgers organization that earned him $800 a month and carried a $20,000 signing bonus. After stints at Reno and Omaha, the 20-year-old third baseman was brought up to the big club where he collected three hits in 11 at-bats in six games. McMullen played in 103 games for the Dodgers over the next two years before being traded to the Washington Senators for the 1965 season. He spent six years with Washington, then two years playing for the California Angels, followed by three more with the Dodgers, and one each for Oakland and Milwaukee. McMullen was a good defensive infielder and hit with power. He clubbed 156 home runs over a 16-year career that included eight seasons in which he averaged 17 homers.

Randy Elliott was born in Oxnard and played for Camarillo High. He was selected in the first round (24th overall) by the San Diego Padres. He made his debut on September 10, 1972, and was brought up again by the Padres at the end of 1974. The Giants signed him at the end of the 1976 season. Elliot played in a career-high 73 games in 1977, sharing the outfield with Jack Clark, Darrell Evans, and others. Elliott also played in 14 games for Oakland in 1980.

THE MAJORS

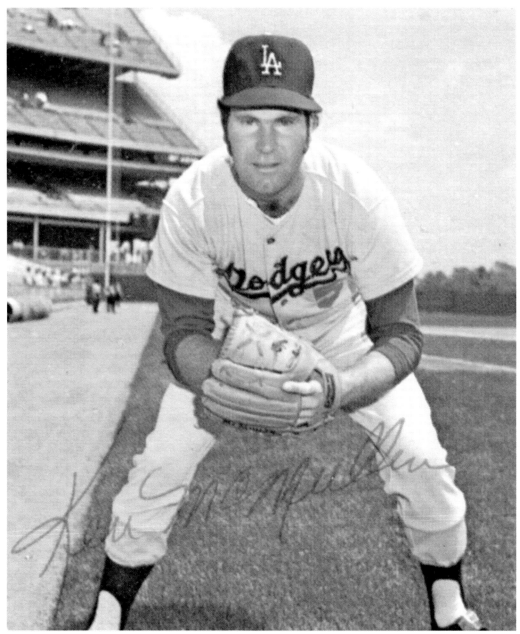

Such luminaries as Walter Alston, Gil Hodges, Ted Williams, Jim Lemon, Lefty Phillips, and Chuck Tanner managed Ken McMullen. He was a figure in several big trades. In 1964, McMullen was traded by the Dodgers, along with Dick Nen, Pete Richert, Phil Ortega, and Frank Howard, to the Senators for John Kennedy, Claude Osteen, and cash. From the Senators in 1970, McMullen was traded to the Angels for Rick Reichardt and Aurelio Rodriguez. From the Angels in 1972, McMullen was traded back to the Dodgers, along with Andy Messersmith, for Bobby Valentine, Billy Grabarkewitz, Mike Strahler, Bill Singer, and Frank Robinson.

Mike Parrott was born in Oxnard and graduated from Camarillo High, where he pitched two no-hitters and three one-hitters, posting a 0.47 ERA. The 6-foot, 4-inch pitcher was a first-round draft pick (15th overall) of the Baltimore Orioles in 1973. He made his debut with the Orioles on September 5, 1977. He was traded in the off-season to the Seattle Mariners and set a club record with 14 wins. Parrott won 67 games over his career of five years in the majors and six in the minors.

Kevin Gross pitched four years of varsity baseball at Fillmore High before moving on to Oxnard College and California Lutheran University. He was then drafted by the Philadelphia Phillies in the first round (11th overall). Gross pitched in the first night game ever played at Chicago's Wrigley Field. In 1988, he became the first player from Ventura County to play in a Major League All-Star Game (although Jim Colborn was the first to be selected as an All-Star in 1973). Kevin was traded in 1989 to the Montreal Expos and then signed as a free agent in 1991 with the Dodgers, for whom he pitched a no-hitter against the Giants in 1992. He earned double-digit victories in seven seasons, with a career-high 15 wins in 1985.

THE MAJORS

Eric King was born in Oxnard in 1964 and pitched for Royal High in Simi Valley. The San Francisco Giants, who traded him before the 1986 season to Detroit, signed him as undrafted free agent in 1980. He made his debut with Detroit on May 15 against the Texas Rangers, giving up just one hit in five and one-third innings. He won 11 games in 1986 and a total of 10 more the following two years before being traded to the White Sox. King's best year was 1990, when he went 12-4 with a 3.28 ERA in 151 innings. King was out of baseball after the 1992 season. The 34 year old attempted a comeback in 1998, when he played for the Pacific Suns of the independent Western Baseball League. The team played its games at Oxnard College, and neither the team nor King had a successful season.

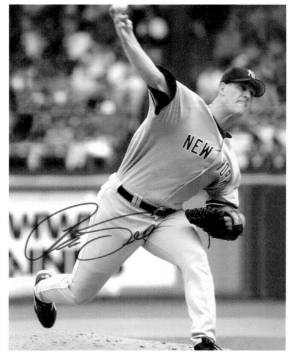

Aaron Small is a study in perseverance. Small was born in Oxnard and attended Lost Hills High School in Covina. The 6-foot, 5-inch pitcher was drafted by the Toronto Blue Jays in the 22nd round in 1989. After pitching for 20 teams since his 1994 debut, the majority of them in minor-league cities, the 33-year-old Small made history by winning all 10 games in which he pitched for the New York Yankees in 2005. The achievement made him one of only four major-league pitchers ever to record at least 10 victories without a defeat in a season.

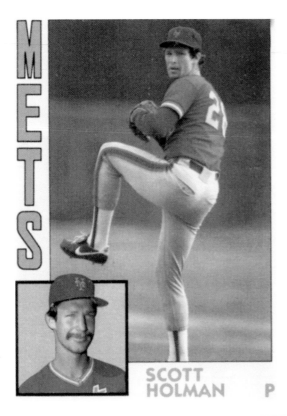

SCOTT
HOLMAN P

Scott Holman was born in Santa Paula and began playing professionally for Wausau in the Midwest League in 1977. By 1979, he was signed as an undrafted free agent by the Mets. The next year, Holman made it to the majors and pitched in four games. Holman pitched in four more games in 1982. In 1983, in his final year with New York, he appeared in 35 games and pitched in 101 innings.

Bryan Corey played high school ball at Thousand Oaks. Drafted in the 12th round as a position player in 1993 by the Detroit Tigers, he was converted to a pitcher in 1995. Three years later, Corey made his debut with the expansion Arizona Diamondbacks. After three appearances, he was sent down to the minors. He resurfaced in 2002 with the Dodgers and pitched one lone scoreless inning. Four more years went by before the Texas Rangers gave him a chance; he appeared in 16 games, posting a 1-1 record with an impressive 2.60 ERA. In an attempt to bolster their middle-relief staff for the pennant run, the Red Sox acquired Corey, who picked up his first Boston victory at Fenway Park.

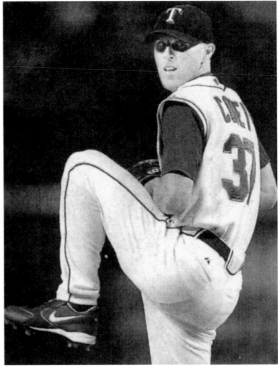

Kameron Loe was born in Simi Valley and attended Granada Hills High and Cal State, Northridge. In 2002, the Texas Rangers drafted the 6-foot, 8-inch right-hander in the 20th round. Within two years of signing, Loe made it to the majors, bringing along his 7-foot boa constrictor, Angel. In Loe's two full years with the club, he collected 12 wins and pitched in 177 innings.

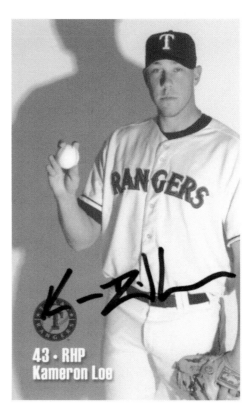

43 · RHP
Kameron Loe

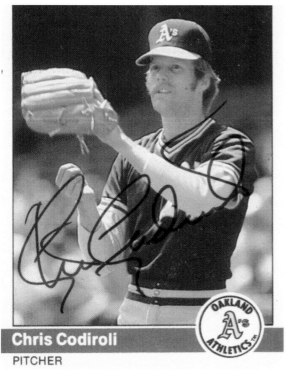

Chris Codiroli

PITCHER

Chris Codiroli was born in Oxnard in 1958 and made his major-league debut in 1982 with the Oakland A's. He was a first-round pick (11th overall) by the Tigers in the 1978 draft out of San Jose State University. In 1983, Codiroli won 12 games. In 1985, Chris led the American League in starts with 37, winning a career-high 14 games. In 1987, he signed as a free agent by the Indians and made his last major-league appearance as a member of the Kansas City Royals in 1990.

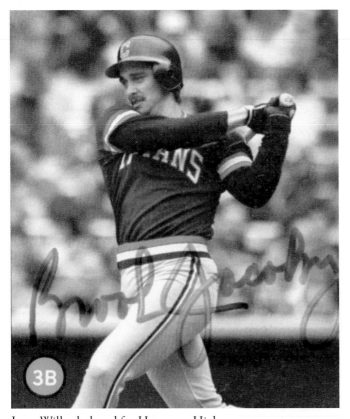

Brook Jacoby graduated from Buena High in Ventura and was drafted in the seventh round by the Atlanta Braves in 1979. He made his major-league debut on September 13, 1981, with Atlanta. Traded in 1984 to Cleveland, he became the Indians' regular third baseman. Brook's career was highlighted by two All-Star nominations in 1986 and 1990. He posted a career-high home run total of 32 in 1987 to go along with a batting average of .300 for the season.

Jerry Willard played for Hueneme High and Oxnard College before signing with the Philadelphia Phillies in 1979 as an undrafted free agent. Willard made his debut on April 11, 1984, for the Cleveland Indians and hit 10 home runs in 87 games. He played 11 professional seasons, including parts of eight seasons with six different teams on the major-league level. Willard left his biggest mark on the game with the Atlanta Braves. In the fourth game of the 1991 World Series, Willard faced Minnesota Twins reliever Steve Bedrosian with one out, the scored tied 2-2, and Mark Lemke on third base. With the nation watching and Ventura County rooting, Willard lofted a fly ball to right field that was just deep enough to give Lemke a chance to beat the throw and tag, which he did, to even up the series.

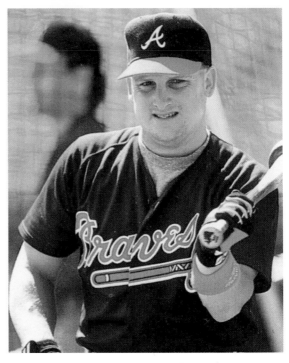

THE MAJORS

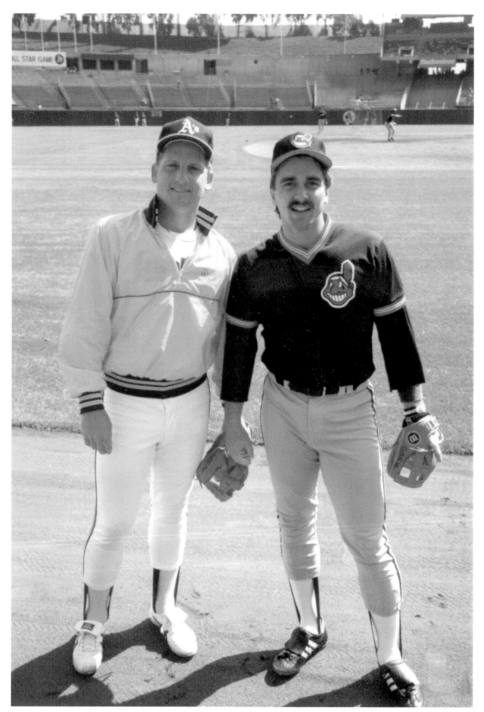

Jerry Willard and Brook Jacoby pose for fellow Ventura County player Roger Frash, who snapped this photograph while attending an A's-Indians game in Oakland. Jacoby joined another Ventura County native, Mark Berry, on the Cincinnati Reds coaching staff when he was appointed the team's hitting instructor for the 2007 season.

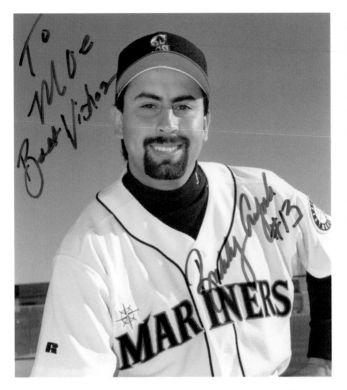

Bobby Ayala graduated from Rio Mesa High School in 1988. He went undrafted but impressed the Cincinnati Reds scouts at a June 1988 public tryout. Four years later, he made his major-league debut with the Reds. He was traded to the Seattle Mariners for the 1994 season and posted a career-best 2.86 ERA with 76 strikeouts in almost 57 innings.

Scott Radinsky graduated from Simi Valley High in 1986, having posted an 18-1 record in his two varsity years, and was a third-round draft pick by the Chicago White Sox that year. In his first year in the big leagues for the White Sox in 1990, Radinsky went 6-1 in 62 games . He appeared in a career-high 73 games for the Sox in 1993 while going 8-2. He posted a career ERA of 3.44. Radinsky has played and sung in several local bands, including Sacred Straight, Ten Foot Pole, and Pulley.

THE MAJORS

Tim Laker played his amateur ball at Simi Valley High and Oxnard College. He was chosen by Montreal Expos in the sixth round of the 1988 draft. Laker has played parts of 11 seasons in the major leagues, making his debut with the Expos in 1992. The catcher has also played for Tampa Bay, Baltimore, Pittsburgh, and Cleveland.

Steve Hovley graduated from Villanova Prep and Stanford University. The California Angels drafted him in the 35th round in 1966, but the Seattle Pilots later chose him in the 1968 expansion draft. A free spirit, Hovley came to the attention of teammate Jim Bouton, who wrote the tell-all book *Ball Four* about the 1969 Seattle season. Bouton nicknamed Hovley "Orbit," because as the pitcher reported, the outfielder liked to read Dostoyevsky and let his crew cut grow so as to not discriminate against any particular hair. Hovley is also quoted as saying, "To a pitcher, a base hit is the perfect example of negative feedback." Hovley played five years in the majors.

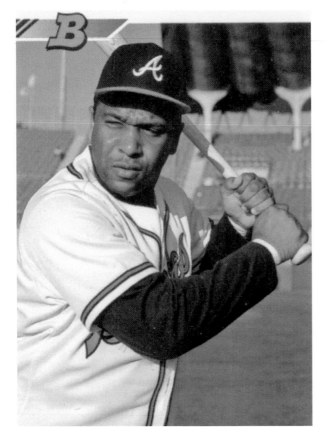

Terry Pendleton played for the Channel Island Raiders, Oxnard College Condors, and Fresno State University. Pendleton was drafted in the seventh round of the 1982 draft by the St. Louis Cardinals. He made his major-league debut two years later for the Cardinals, on July 18, 1984, going 3-for-5 with an RBI. He appeared in 67 games his rookie season and batted .324.

Between 1984 and 1990, Terry Pendleton was part of the one of the best infields of the times. The Cardinals featured Pendleton at third base, Ozzie Smith at shortstop, Tommy Herr at second, and Jack Clark at first base. St. Louis reached the World Series in 1985 and 1987.

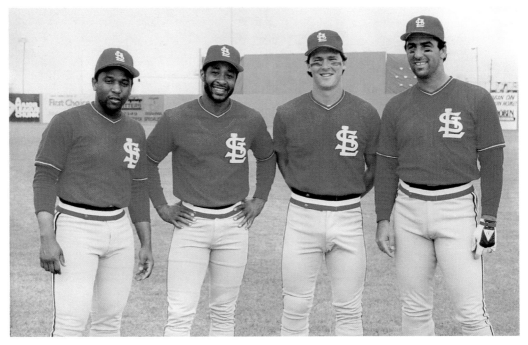

THE MAJORS

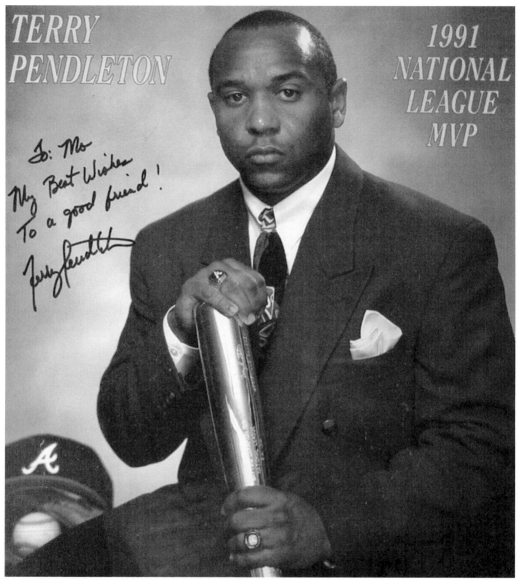

Before the start of the 1991 season, Terry Pendleton signed as a free agent with Atlanta Braves and led them to their first divisional championship since 1982. Pendleton led the National League in batting average (.319), hit 22 home runs, posted a .517 slugging percentage, and drove in 86 runs to earn the Most Valuable Player Award. He came in second in the MVP voting the next year with a .311 average, 21 home runs, and 105 RBIs. He won three Gold Glove Awards at third base in 1987, 1989, and 1992. Pendleton retired after the 1998 season. After a 15-year major-league career, Pendleton rejoined the Braves for the 2002 season as the team's hitting instructor. Pendleton is credited for helping Andruw Jones's offensive numbers, which earned him MVP consideration.

Steve Sisco is from Thousand Oaks and was drafted out of the Cal State Fullerton in the 16th round by the Kansas City Royals in 1992. He was signed by the Braves organization in 1998 as a player who consistently batted near the .300 mark in the minors. Persistence paid off, and Sisco finally made his debut with Atlanta in 2000 at the age of 30. Steve participated in 25 games for the Braves' Division Championship team.

Drafted out of California Lutheran University by the Houston Astros in the second round of the 2003 draft, the 6-foot, 8-inch Jason Hirsh used his 97-mile-an-hour fastball at Cal Lutheran to post a 26-6 record, striking out a school-record 18 batters in a game. He earned Texas League Pitcher of the Year honors in 2005 by overpowering minor-league opposition. He started the 2006 season with a 13-2 record before he was called up to the majors, making his debut on August 12, 2006. Hirsh went on to start nine games for the Astros, collecting three wins and holding opposing hitters to a .231 average. Hirsh was traded in the off-season to Colorado.

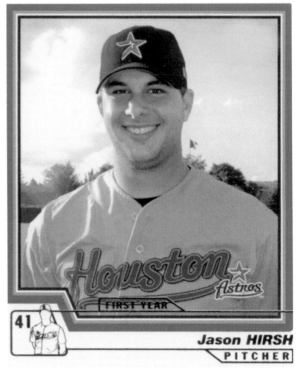

THE MAJORS

Brandon Knight was born in Oxnard and attended Buena High School in Ventura and Ventura College. Knight was selected in the 14th round by the Texas Rangers in 1995 and traded to the New York Yankees in 1999 with Sam Marsonek for Chad Curtis. By 2001, Knight made the Triple-A All-Star Team and was called up to the big club the same year. Knight was brought up the following year also and ended up pitching in a total of 11 major-league games.

Kurt Stillwell's father, Ron Stillwell, played parts of two seasons with the Washington Senators. Ron's career was cut short due to a collision during a game. Kurt attended Thousand Oaks High, which produced several high draft picks, some who made it to the major leagues: Gregory Smith (1968), John Phillips (1970), Gary Trumbauer (1971), Chuck Crim (1982), Kurt Stillwell (1983), Jack Wilson (1992), and Bryan Corey (1993). Kurt Stillwell played nine seasons in the majors, his best being 1988 when he was selected to the American League All-Star Team. While with the Reds, Manager Pete Rose nicknamed Kurt "Opie" after Ron Howard's role on *The Andy Griffith Show*.

Chuck Crim was drafted in the third round by the Chicago Cubs in 1979 after his senior year at Thousand Oaks High School and again in 1982 by the Milwaukee Brewers, dropping to the 17th round. Crim put in eight years in the majors, pitching for the Brewers, Angels, and Cubs. He collected 47 victories and posted a respectable 3.83 ERA.

Gabe Kapler played for coach Mario Porto's Moorpark College club in 1995. Despite being drafted in the 57th round by the Detroit Tigers in 1995, Kapler reached the majors by the 1998 season. As bodybuilder featured in magazines, Kapler defied long-held assumptions that lifting weights negatively impacts a player's flexibility. In his first full season, Kapler hit 18 home runs in 400-plus at bats, followed by seasons of 14 and 17 long balls in Texas. In 2000, Kapler hit .302 for the Rangers, which included a 28-game hitting streak. He then played for Colorado and parts of four seasons for the Boston Red Sox. Shortly after contributing to the Bosox's first World Series in 70 years, Kapler signed on to play for the Yomiuri Giants in Japan. Kapler returned to the Sox the next season, platooning with Trot Nixon in right field.

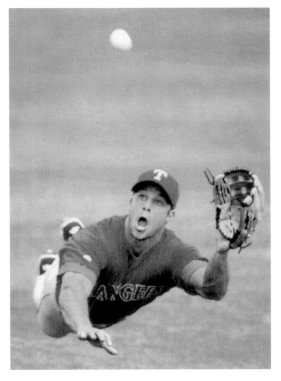

THE MAJORS

In addition to Kapler's on-field accomplishments, he has been recognized for his contributions off the field. He was voted into the Southern California Jewish Hall of Fame in 2006. Kapler and his wife, Lisa, have also set up a family-run nonprofit organization, The Gabe Kapler Foundation, to help curb domestic violence. The foundation works with organizations that operate transitional shelters for victims of domestic violence. Kapler retired as a player after the 2006 season.

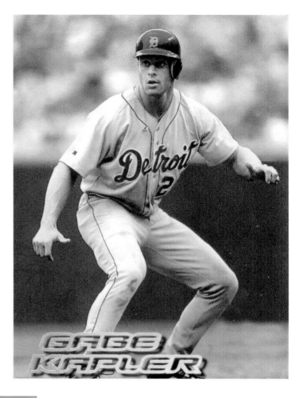

Darren Reed was born in Ojai, graduated from Ventura High, and played for Ventura College. He was chosen in the third round by the New York Mets in the 1984 draft. He made his debut on May 1, 1990, with the Mets against the Atlanta Braves. Reed appeared in 26 games that year, then 42 games in 1992 for the Montreal Expos, and a final 14 games that same season with the Minnesota Twins. He was traded back to the Mets in the off-season but did not return to the majors.

bobby AYALA

The Seattle Mariners held a Bobby Ayala Goatee Night in 1995 in which fans with a goatee could purchase discounted tickets. Ayala played for the Montreal Expos and the Chicago Cubs in 1999. He ended his career pitching for the Dodgers Triple-A affiliate, the Albuquerque Dukes.

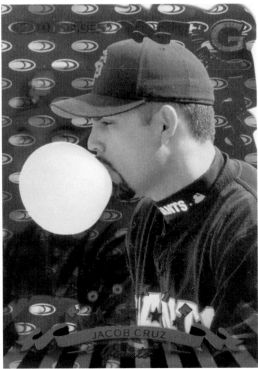

Jacob Cruz graduated from Channel Islands High School in 1991. He was drafted by the California Angels in the 45th round, but chose to attend Arizona State, for whom he batted .393 in his junior year. The San Francisco Giants drafted Cruz in the first round (32nd overall) in 1994. He debuted with the Giants in 1996.

THE MAJORS

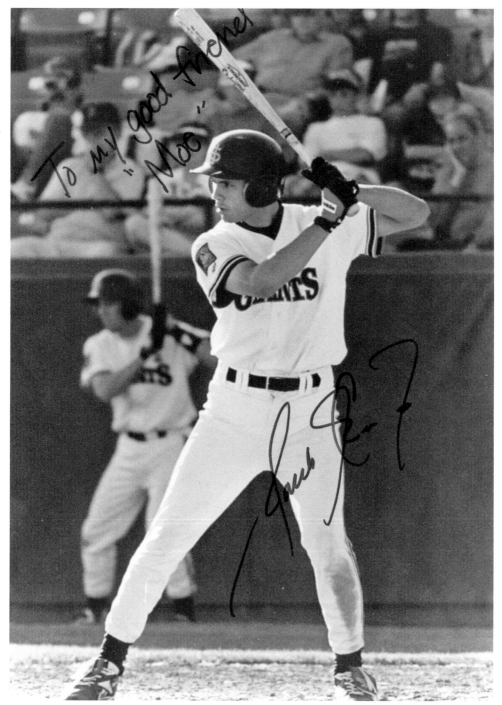

From the Giants, Cruz went to the Indians, Tigers, and Reds. Jacob's most successful season in his nine-year career was 2005, when he was tied for the league lead in pinch hits, 20, including three pinch-hit home runs that led the league. Jacob posted his highest average in 1999, when he had 29 hits in 88 at bats for a .330 average.

Dmitri Young made his debut with the St. Louis Cardinals on August 29, 2006. At the end of the 1997 season, he was drafted by the Tampa Bay Devil Rays in the expansion draft, which dealt Young to the Reds. Young consistently hit over .300 in his four years with the Reds before being traded to the Detroit Tigers for the 2002 season.

THE MAJORS

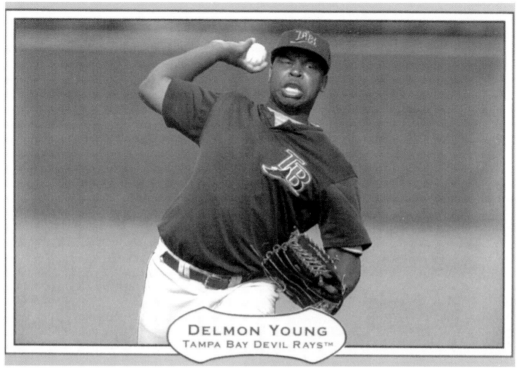

DELMON YOUNG
TAMPA BAY DEVIL RAYS™

Delmon Young's debut in the majors came on August 29, 2006, exactly 10 years to the day that his older brother, Dmitri, made his first plate appearance. Batting for the Devil Rays, Delmon Young clouted two hits in his first three at-bats, one a home run. Young was beaned by Freddy Garcia of the White Sox, some speculating that it was retaliation for the bat Young tossed at a minor-league umpire earlier in the year, which cost the player a 50-game suspension.

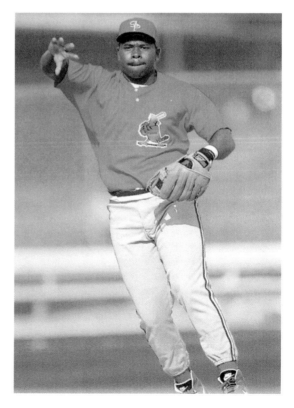

In Detroit, Dmitri Young continued to put up strong numbers, sacrificing his batting average for power. Young hit 29, 18, and 21 homers from 2003 to 2005, earning a spot on the 2003 American League All-Star Team. On April 4, 2005, Young hit three home runs on opening day, joining George Bell and Tuffy Rhodes as the only players in baseball history to perform that feat.

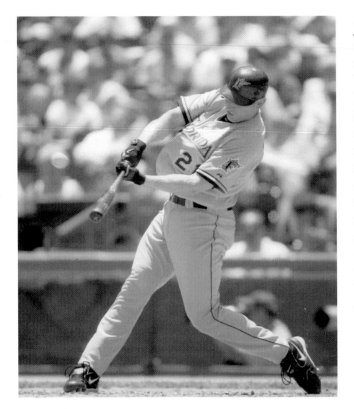

Joe Borchard was chosen in the first round (12th overall) in the 2000 draft by the Chicago White Sox. His father, Joe Borchard Sr. was drafted by Kansas City in 1969. Joe Jr. made his major-league debut for the Sox two years later, on September 2, 2002, blasting a home run in his first at-bat against Corey Thurman. Joe made 239 appearances in 114 games during his four-year tenure with the big club. He was traded to the Seattle Mariners for a short six-game stay before moving on to the Florida Marlins for the majority of the 2006 season.

Jack Wilson was born in Westlake Village and played for Thousand Oaks High and Oxnard College. Wilson received offers to play Division I soccer, but instead focused on his shortstop skills and was chosen by the St. Louis Cardinals in the ninth round of the 1998 amateur draft. Traded to the Pittsburgh Pirates, Wilson made his major-league debut on April 3, 2001, going one-for-two. Excellent with the glove and possessing a strong arm, Wilson was selected to the 2004 National League All-Star Team and batted .308 for the season. His 201 hits marked the first time a Pirates shortstop attained 200 since Honus Wagner did it in 1908.

THE MAJORS

The Chicago Cubs selected Westlake High graduate Matt Franco in the seventh round of the 1987 draft. He made his debut in 1995, and in 1996 was traded to the New York Mets. By 2003, the left-hand-hitting Franco had put in eight years in the majors, batting .267 for his career. In 2004, Franco traveled to Japan and played for the Chiba Lotte Marines team, slugging 16 home runs and batting .278.

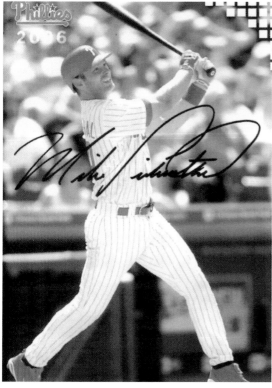

Mike Lieberthal was the Philadelphia Phillies' first-round pick (third overall) in the 1990 amateur draft. He debuted in the majors on June 30, 1994, going one-for-three from the plate. By 1999, Lieberthal was on his way to becoming an All-Star, making the team a second time in 2000. He also earned a Gold Glove for his work behind the plate in 1999. Despite hitting .313 in 2003, Lieberthal wasn't selected as an All-Star. After 13 seasons and 1,174 games, mostly as a catcher, and with a solid .275 average and 150 career home runs, Lieberthal returned home for the 2007 season when he signed to play for the Los Angeles Dodgers.

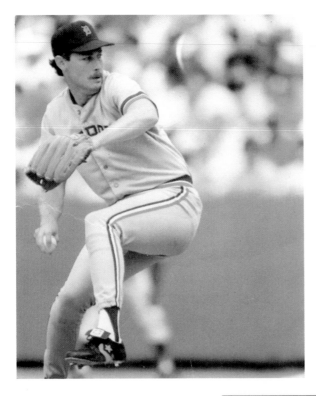

Jeff Robinson was born in Ventura in 1961 and drafted in the third round in 1983. He made his debut on April 12, 1987, pitching seven innings, striking out five, and giving up only one run for his first major-league victory. In his six years with Detroit, Baltimore, Texas, and Pittsburgh, Robinson collected 47 victories, posting a career-high 13 in 1988 with the Tigers.

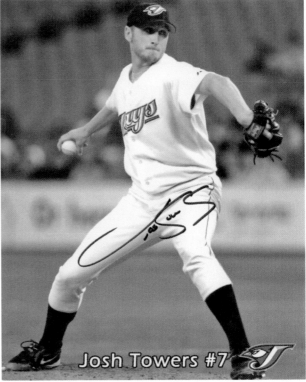

Josh Towers #7

Josh Towers pitched a total of 140.3 innings in his rookie year, earning eight victories for the Baltimore Orioles. Towers picked up eight more victories against one loss while pitching for Toronto in 2003, followed by nine victories in 2004. In 2005, he logged 13 wins in career-high 208 innings. Two more victories in 2006 brings 40 career wins into the 2007 season. During the off season, Towers helps his uncle and Oxnard College coach Roger Frash raise money for his former team.

Jered Weaver and his agent, Scott Boras, held out for a $4 million signing bonus, which came in May 2005 from the Los Angeles Angels. Weaver made his major-league debut one year later, on May 27, 2006, pitching seven shutout innings and going on to tie an American League record held by Whitey Ford—posting nine consecutive victories to start a career. Weaver ended the year with an impressive 11-2 record and 2.56 ERA. Before every start, Weaver writes "EHH" on the back of the mound in honor of his deceased maternal grandparents, Ed and Helen Hamlin.

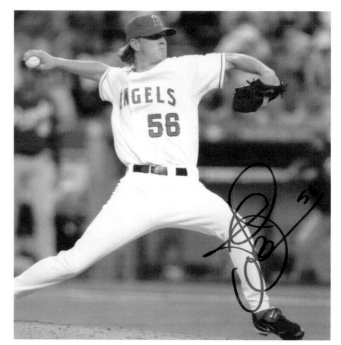

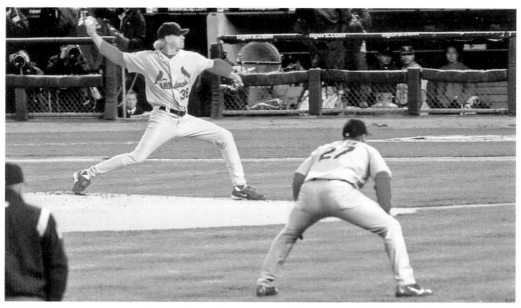

Jeff Weaver's postseason efforts will go down as one of the most unlikely and solid performances of all time. After posting a 6.29 ERA with the Angels in 2006, Weaver was put on waivers. Courageously, he won five games for the Cardinals down the stretch to help the sliding St. Louis Cardinals make the playoffs. Once the team scratched into the postseason, Weaver continued his newly found pitching form and recorded three more victories for the team, including the stellar eight-inning, four-hit, nine-strikeout performance in the clinching game of the World Series against the Tigers, the team that originally drafted him.

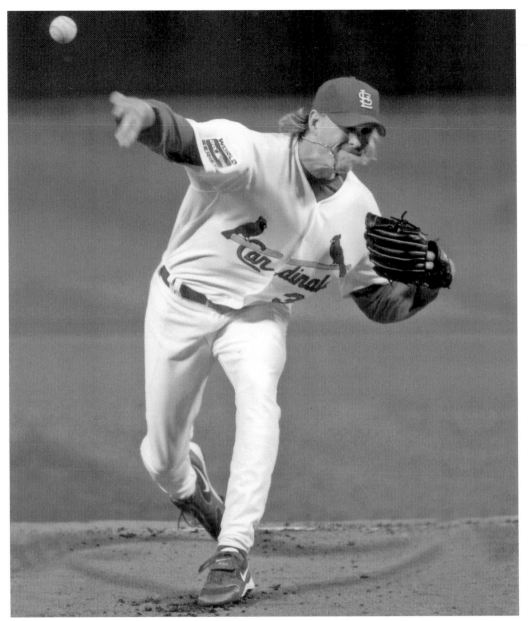

Jeff Weaver graduated from Simi Valley High before attending Fresno State University, where his pitching abilities caught up to his 6-foot, 5-inch frame. He was drafted in the first round (14th overall) by the Detroit Tigers. After showing signs of dominance and posting a 3.18 ERA during the 2002 season, the New York Yankees traded for Weaver in July to help bolster their postseason pitching rotation. After a disappointing appearance in the 2003 World Series, in which he gave up a home run to Alex Gonzales, the former Simi star was traded to the Dodgers, where his numbers consistently improved. After two years with Los Angeles, free agency landed Weaver with the Angels. After a 3-10 start, he was put on waivers and picked up by the Cardinals, where he became one of their World Series heroes.

THE MAJORS

Noah Lowry pitched for Nordoff in Ojai and Pepperdine University. He was selected as West Coast Pitcher of the year in 2001 before being drafted by the San Francisco Giants in the first round (30th overall). Lowry made his major-league debut in 2003, and the next year he went 6-0 with an ERA of 3.82 and was selected to the All-Rookie Team. Lowry increased his win total to 13 the following year and adding 7 more in 2006.

Steve Trachsel was born in Oxnard and attended Troy High, Cal State Fullerton, and Long Beach State. He was drafted by the Chicago Cubs in the eighth round in 1991. On September 19, 1993, Trachsel made his major-league debut, pitching six innings, striking out five, and giving up two earned runs. By 1996, Trachsel was named to the National League All-Star Team on the way to winning 13 games. He claimed 15 victories in 1998. On the opposite side, he lost 18 games in 1991 and another 15 in the American League in 2000. After giving up four home runs in one inning for the New York Mets in 2001, Trachsel was sent to the minors, where he regained his form.

Robert Fick played for the Newbury Park Panthers and the Northridge Matadors. The Detroit Tigers selected Fick in the fifth round of the 1996 draft after he earned Western Athletic Player of the Year honors. He made his debut with the Tigers two years later and collected eight hits in only 22 at bats for a .364 start to his major-league career. Other Panthers to reach the majors include Tyler Johnson, who was drafted in the 34th round in 2000 by St. Louis, making his major-league debut in 2005, and David Lamb, who was drafted in the second round by Baltimore and played shortstop for three seasons between the Devil Rays, the Mets, and the Twins.

Robert Fick clubbed the last home run at Tiger Stadium, on September 27, 1999, a grand slam off Kansas City Royals pitcher Jeff Montgomery in the eighth inning. It was the last hit and the 11,111th home run at the stadium, the site of 12-time American League batting champion Ty Cobb's career as well as the venue for Babe Ruth's 700th home run and Reggie Jackson's mammoth dinger in the 1971 All-Star Game. The ballpark also was used to film the movie 61*.

Paul McAnulty played for the Yellow Jackets in Oxnard as well as for the Oxnard College Condors and the Long Beach State Dirtbags, where he was the teammate of Jeremy Reed and Jered Weaver. The Padres drafted McAnulty in the 12th round in 2002. In the minors at Idaho Falls, the sweet-swinging McAnulty batted .379, followed by a .344 average at Portland for the Padres Tripe-A club in 2005.

On September 6, 2006, Paul McAnulty is shown mobbed by his teammates after hitting his first major-league home run off Nate Field in the 11th inning at Petco Park, giving the San Diego Padres a fifth consecutive victory in a drive for the divisional lead. His parents attended the game, and the blast made ESPN's *SportsCenter* highlights. All those hours at his family's business, the "Who's on First" batting cage, had finally paid off.

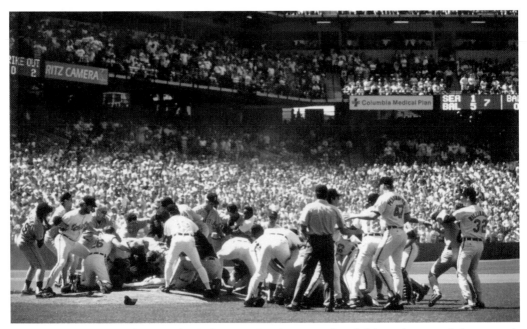

In a 1993 game of retaliation, the Baltimore Orioles were ahead 5-1 in the top of the seventh inning. Seattle pitcher Chris Bosie had given up home runs to Mike Devereaux in the fourth inning and Harold Baines in the fifth. Bosie threw behind Oriole batters Harold Reynolds and Mark McLemore. Oriole pitcher Mike Mussina then hit Seattle catcher Bill Haselman with a pitch. Haselman had previously hit a home run off Mussina for the Mariners only run.

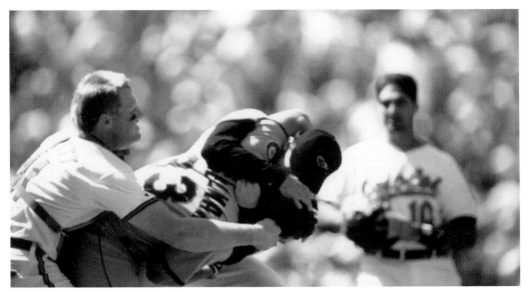

According to Orioles catcher Jeff Tackett, the fight started at the mound and moved over to third base, then back to the mound, then toward home plate, and finally concluded at the point of origin. Twenty-five minutes later, order was restored. Tackett got one hit in the game and several on the field.

THE MAJORS

The Baltimore Orioles chose Tackett in the second round of the 1984 draft. He made his major-league debut on September 11, 1991. The 6-foot, 2-inch catcher played parts of four seasons with the big club. Though Tackett was primarily a catcher, he did get in an inning of work on the mound, giving up one walk and retiring the side without giving up a hit.

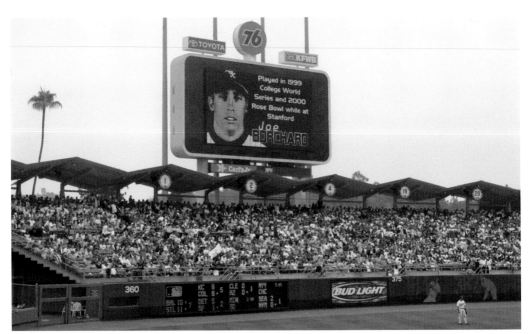

Highlights of Joe Borchard's young career were displayed to the Dodger Stadium crowd, including dozens of family and friends, on "Diamond Vision" during the White Sox visit to Dodger stadium.

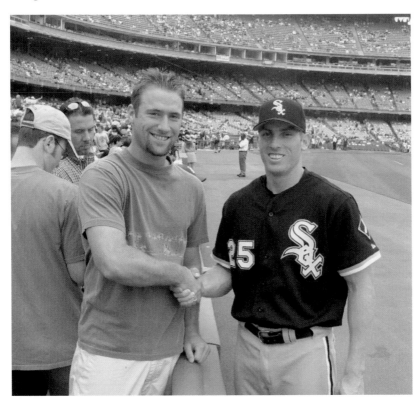

Brian Borchard (left) greets cousin Joe Borchard at a game at Dodgers Stadium during the 2002 season. Brian's 90-plus-mile-per-hour fastball was leading him toward a career in baseball, but arm troubles unfortunately curtailed his chance to join Joe in the major leagues.

THE MAJORS

The Hueneme/Oxnard boys meet up with fellow county product Mark Berry at Dodgers Stadium at a game in 2006. Pictured here from left to right are Andy Martinez, Phil Ramirez, Jerry Willard (in sunglasses), Jon Larson (in front) Keith De La Huerta, Mark Berry (Reds coach), Steve Burleson, Ray Gallardo, Craig "Moe" Maulhardt (sunglasses on hat), Steve Santora (sunglasses on forehead), Roger Frash, and Ron Lorea.

The 1994 Doctor Dewey's Baseball Classic annual golf tournament featured several former big leaguers. Organized by Roger "Dewey" Frash as a way to get friends together during the holidays, the tournament ran for nine years. The 1994 tournament was held at the River Ridge Golf Course in Oxnard. Posing here from left to right are Brook Jacoby, Jerry Willard, Roger Frash, Ken McMullen, Steve Thomas, and Terry Pendleton. Other celebrities participated, including Dick Butkus and Jim Colborn.

While playing for the 2005 Double-A Montgomery team, Delmon Young hit .336 with 20 home runs and 71 RBIs in only 84 games. Young was called up to Tampa Bay at the end of the 2006 season. With 30 games left, he batted 126 times, 4 at-bats short of qualifying for his official rookie season. During this span, Young collected 40 hits, giving him a .317 average and a .467 slugging percentage. In terms of talent, Delmon has the ability to be the best player ever to come out of Ventura County.

THE MAJORS

BIBLIOGRAPHY

athletics.venturacollege.edu

Bucek, Jeanine, ed. dir. *The Baseball Encyclopedia: The Complete and Definitive Record of Major League Baseball* (10th edition). New York: MacMillan USA, 1996.

Camarillo Varsity Baseball Season Summary Booklet 2002. Compiled by Scott Cline, Camarillo, CA, 2002.

Elfers, James. *The Tour to End all Tours.* University of Nebraska Press, 2003.

Light, Jonathan Fraser. *The Cultural Encyclopedia of Baseball.* Jefferson, NC: McFarland & Company, Inc., 1997.

Maulhardt, Jeffrey Wayne. *The Day the New York Giants Came to Oxnard.* Oxnard, CA: MOBOOKS, 1997.

www.baseball-reference.com

www.oxnardcollege.edu

www.thebaseballcube.com

www.vcshf.com

The author is seen here with Pete Rose, who stroked out a major league–record 4,256 hits, mostly with the Cincinnati Reds. Rose attended one of Maulhardt's book signings bringing an autographed baseball. Actually, the author paid for the autograph, but it was well worth it. Rose also knows Oxnard from his friendship with Leo Bunnin, an automobile-dealership owner.

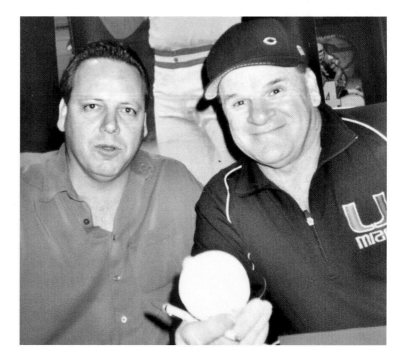

Discover Thousands of Local History Books
Featuring Millions of Vintage Images

Arcadia Publishing, the leading local history publisher in the United States, is committed to making history accessible and meaningful through publishing books that celebrate and preserve the heritage of America's people and places.

Find more books like this at
www.arcadiapublishing.com

Search for your hometown history, your old stomping grounds, and even your favorite sports team.

Consistent with our mission to preserve history on a local level, this book was printed in South Carolina on American-made paper and manufactured entirely in the United States. Products carrying the accredited Forest Stewardship Council (FSC) label are printed on 100 percent FSC-certified paper.

MADE IN THE USA